GW00771868

LONDON COFFEE

London Coffee
First Edition

Copyright © Hoxton Mini Press 2017

All text © Lani Kingston
All photographs © David Post
except images on p.8 & 10 courtesy
Getty Images, image on p.11 courtesy
Monmouth Coffee. Illustration on p. 26
courtesy Adam Dant.

Design and layout by EverythingInBetween.
Sequence by Hoxton Mini Press,
Lani Kingston and David Post.
Copyediting by Liz Marvin

Song lyrics quoted p. 128
© Ray Gelato, courtesy of Ray Gelato

A CIP catalogue record for this book
is available from the British Library

ISBN 978-1-910566-25-1

First published in the United Kingdom in 2017
by Hoxton Mini Press

Printed and bound by: Livonia Print, Latvia

To order books, collector's editions
and signed prints please go to:
www.hoxtonminipress.com

Written by Lani Kingston
Photography by David Post

LONDON COFFEE

The people, the places, the history

HOXTON MINI PRESS

CONTENTS

FOREWORD by Anette Moldvaer

When I first arrived here 14 years ago, the coffee scene in London left a lot to be desired. In spite of the committed work of a handful of established roasteries and cafés, the market didn't just feel underserved, it felt underestimated. I'd spent years working as a barista in a small country at the top of the coffee consumption statistics, and the potential in London seemed immense to me. Soon enough, the feeling of it being close to a tipping point inspired the launch of Square Mile Coffee Roasters.

After travelling extensively to cities across the world where vibrant coffee cultures had already been established, the motivation was to be a catalyst for the same in London, as well as the rest of the UK. We wanted to bring back the days of coffeehouses as community gathering spots, where people could meet, talk and take pause in a hectic day. But we wanted them to do it over a truly delicious cup of coffee that everyone had lovingly cared for, from the producers through to the baristas.

It may have seemed a big risk to take, but the reasons why I loved London were the reasons we knew it would work. The energy of this melting pot; this city of dreamers, explorers and fighters, was the drive behind setting up a 15kg roaster under a railway arch in Bethnal Green and opening the doors to anyone who wanted to come talk coffee. If professionals and enthusiasts could be connected and inspired, the market of suppliers and consumers could be expanded.

A lot of faith was drawn from seeing how welcoming London was to people who had new ideas, new perspectives and new proposals. If you're doing something interesting and something different, this city will find you, and it will challenge you. But ultimately, if what you are doing has quality and heart, London will have your back.

It's a particular privilege to be part of something from its inception – be it a company, a community or a movement. Over the years a lot has changed for London's coffee. From that handful of independent cafés flying the flag for specialty coffee as we knew it, we now have hundreds of coffee shops preparing and serving a wide array of beans and brew methods, placing London firmly at the top of the list of cities for good coffee. This is thanks

to the collective efforts of the passionate baristas, shop owners, roasters and importers who have created a whole new field of opportunities for growth. It's also thanks to the consumers and customers that sought us out, embraced us and returned to us. The beans are just one part of the puzzle; the food, atmosphere and service all play their part.

In coffee, we know we have to work together to get things done. We have to take a holistic approach to the entire system, caring for each element with respect and a will to constantly improve. This is why London's coffee deserves to be celebrated in a book: to give us a chance to reflect on how far we've come, and set a course for where we want to go next.

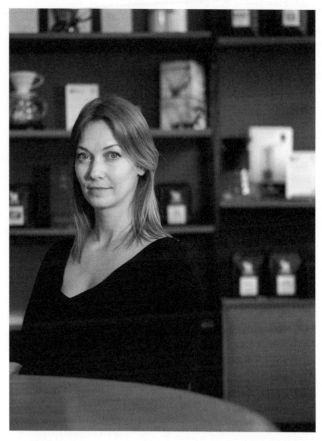

Anette Moldvaer, co-founder, Square Mile Coffee Roasters

INTRODUCTION by Lani Kingston

The omnipresent coffee shop. Where a wanderer can take refuge from the crisp, cold London air, in which every shivering breath outside dances a misty pirouette. The warm chatter of the morning baristas and the bubble of steam and the hiss of foaming milk: this is the universal sound of hospitality and welcome, inviting in writers, poets, actors, cockneys, plumbers, firemen, teachers, chefs and politicians alike.

The twenty-first century coffee drinker has developed a taste for single origin and light roasts; we've come to learn terms such as terroir, crema, microfoam; we read tasting notes and understand what different roasting profiles actually taste like in the cup.

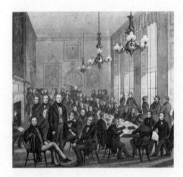

The British Coffee House, Cockspur Street, Westminster, London, 1839

But while each generation of coffee consumer embraces the developments, technology and taste preferences of their time, what is often forgotten is the centuries-spanning, all-consuming romance we've enjoyed with coffee. It is interesting to note, for example, that while Britain is often perceived as a nation of tea-drinkers, it was Britain's coffee-houses that introduced tea to the nation.

London's first coffeehouse opened in 1652, but the brews enjoyed there were a far cry from the finely tuned, perfectly roasted coffees of today. The seventeenth-century English poet, George Sandys, described his first experience of coffee as 'blacke as soote, and tasting not much unlike it'.

But the taste of the coffee itself was almost a sidenote – the caffeinated fervour of the coffeehouse was the main drawcard. Packed with intellectuals, writers, businessmen, dissidents and spies, these were meeting places, hothouses of debate, community gathering places. Books were read and written, deals struck and businesses begun (and failed). All over a cup of water infused with the seeds of a fruit from Africa. Coffeehouses were nicknamed 'penny universities', as men from all walks of life shared stories and knowledge, and anyone could take part for the penny it cost to visit. Many coffeehouses became known for being 'clubhouses' for those sharing a specific interest. These regular gatherings of those interested by science, literature or politics led to the development of many of these coffee-houses into completely different, non-coffee businesses – some of which are still around today.

A coffeehouse near London's docks visited by sailors and merchants doubled as an informal shipping insurance broker, eventually growing into the now global institution of Lloyds of London. The London Stock Exchange, too, started as a group of coffeehouses where merchants and brokers would meet, peruse detailed lists of market prices and make deals.

Sir Isaac Newton is said to have dissected a dolphin in a coffeehouse frequented by members of the Royal Society; the modern newspaper was born in another; and a coffeehouse was also the scene of the ballot box's worldwide debut, where it was introduced to settle hearty disputes about the morning's news.

Despite the rapidly increasing popularity of coffeehouses across the capital, not everyone was sold. As these establishments were exclusively for men, the women of the city grew suspicious of this new drink that was contributing to the long hours their husbands were spending away from home. In 1674, the womenfolk of London launched a Prohibition-style petition against the drink, holding the 'Newfangled, Abominable, Heathenish Liquor called coffee' responsible for many of their 'grand inconveniences'. But whether it was the drink itself or the scintillating company, coffee and the London coffeehouse certainly captivated the attention of many of London's citizens, who rejected the women's petition with a wave of a hand.

As time passed, London coffeehouses became part of the everyday fabric of society. In 1711, a writer for the *Spectator* observed that by about quarter to eight in the morning, students came to his local coffeehouse 'in their nightgowns to saunter away their time... I do not know that I meet, in any of my walks, objects which move my laughter so effectually as those young fellows at coffeehouses, who rise early for no other purpose but to publish their laziness.'

The coffeehouse survived, regardless of petition, regulation and King Charles II's attempts to shut them down. He was concerned that for the cost of a penny anyone could come and discuss politics – he feared they would brew unrest. But in the end it was the coffeehouse's introduction of that 'excellent and by all Physicians approved China drink' – as it was such advertised in 1658 – that eventually led the nation away from coffee and towards tea.

There are many reasons why the trend for tea may have taken hold, not least of which was the influence of King Charles II's queen, a Portuguese princess who brought

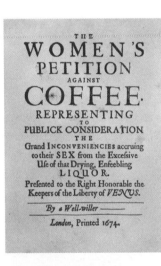

THE
WOMEN'S
PETITION
AGAINST
COFFEE.
REPRESENTING
TO
PUBLICK CONSIDERATION
THE
Grand INCONVENIENCIES accruing to their SEX from the Excessive Use of that Drying, Enfeebling LIQUOR.
Presented to the Right Honorable the Keepers of the Liberty of VENUS.

By a Well-willer ———
London, Printed 1674.

A 1674 petition against coffee by London's women, which came about after coffeehouses became popular among (and exclusive to) men

her love for tea into the aristocratic circles of seventeenth
-century England. It became popular at garden parties and
with women in general, and, after some time, the East India
Company – England's primary importer of tea – was able to
import enough to reduce the price to within reach of the
general public. As coffee was seen as a man's drink only, it
has been suggested that tea rose in popularity because it
was a drink that couples could share, but no doubt it tasted
a lot better than the coffee brewed at the time, too.

Following the Boston Tea Party protest of 1773, coffee
became the patriotic drink of the colonies that formed the
United States. While British consumption of coffee was
waning, in the USA it peaked, leading to a stateside coffee
evolution that brought about the coffee movements we
enjoy today.

Looking back over the history of coffee drinking in
the West, we often refer to a first, second and third 'wave':
three American-origin movements integral in developing
our current coffee culture. 'First wave' coffee is described
as the making of coffee an everyday commodity. Starting
in the 1800s, American brands such as Folgers and Maxwell
House started packaging, supplying in bulk and, as a result,
increasing consumption of coffee at home. 'Second wave'
refers to the proliferation of espresso, the beginning of a
keen interest in quality, and an emphasis on Arabica beans:
one of many varietals, known for producing a superior
flavour. The rise of the coffee chains that grew from the
west coast of America in the 1990s – particularly Starbucks
and Peet's – are usually included in this 'second wave'.

Meanwhile, in the 1950s and 1960s, Britain also
experienced a coffee boom, the likes of which hadn't been
seen since the seventeenth and eighteenth centuries. This
was the era of espresso, and a lot of it was focused in Soho –
brought in by Italians who revived the bomb-damaged area
after the Second World War. The story goes that they were
appalled at what passed for coffee in England at the time
(it was often padded out with chicory or made from a re-
constituted extract, the forebear of today's instant) and set
about bringing the machinery, coffee beans, drink styles and
those friendly neighbourhood cafés from their homelands.

These cafés became musical hubs, home to jazz and
rock 'n' roll and dark, sweet, intense brews. They revived a
war-tired city, and thrived until the 1990s, when the second
wave coffee movement swept in from America. This was the
British coffee drinker's introduction to a whole new variety

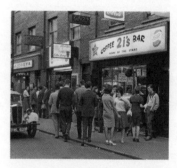

Soho's 2i's coffee bar, where 1960s major
music stars gathered and performed

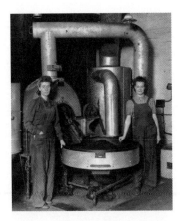

Women roasting circa 1940, on a British-made Whitmee roaster - later bought by Monmouth Coffee Company

of coffee options – the now ubiquitous latte, for one. This time, at least, they were familiar with the basics, so it wasn't long before the concept spread like wildfire.

'Third wave' coffee – the most recent coffee 'movement' – is thus defined by those independent coffee shops, baristas and roasters who focus on the inherent natural flavour of the bean, and a stripping back of syrups, flavours and sugar. Lighter roasts bring out unique flavour notes and levels of acidity. A focus on provenance and terroir has spawned consumer interest in the crop itself like never before, and many companies are now using this awareness to make a positive impact on farmers' lives and plantations in various ways.

While this move away from the chains towards independent stores is often associated with an anti-consumerist, countercultural rebellion against commodity coffee, it was also part of a wider, growing interest in craft food and the resurgence of the artisan career. Consumers were choosing the independent, handmade, unique and individual, and so demand for natural, minimally processed style coffees made by hand grew.

It is anyone's guess as to how the scene (and the people and companies that occupy it) will adapt and grow from here. The next consumers will certainly now have a taste for quality and a bar for excellence, but will perhaps demand a stronger focus on ease and convenience. Innovative businesses in the city are launching exciting new ventures, often using the latest technology as a tool to ensure quality and efficiency. Some artisan roasters have begun making 'high-end' coffee pods, and a number of upmarket cafés who previously reintroduced and championed brewing coffee by hand have started to adopt efficient precision brewing machines.

London is now home to one of the world's most exciting coffee industries. Development happens here at a breakneck pace, meaning the city is now seen as a global leader. With roasteries and cafés now spread across the capital and country, they need to innovate to stay relevant, while meeting customers' high expectations of quality.

As the coffee scene changes, the introduction of sustainable and ethical practices as a force for good, or simply the development of new brewing methods, machinery or logistics, are all ways in which new thinkers are guiding an impassioned and proactive industry into the future. Instead of growing competitive as the industry expands, the coffee scene and the people who have built it are community driven, passionate about social issues, and excited about the future.

Small artisan roasters have now grown, and yet maintain their ethics and philosophies: many now offer their facilities to newcomers to help them roast their own beans. Both private and public funding is directed towards London scientists, enabling research into sustainability and climate change in coffee growing regions. In the coffee shops and roasteries within this book, we meet the likes of tech superstars who are using their skills to develop methods for mass distribution of speciality coffee UK-wide and baristas working with farmers and scientists to create the 'perfect milk' – ethically and in terms of taste – for coffee.

Despite all of this innovation, the London coffee scene is not just about futuristic concepts. Scandinavian coffee bars sell warm cinnamon buns and black coffee in minimalist interiors; Italian espresso bars fill little ceramic cups with deftly pulled shots, just as they have done since the 1950s; family-run Ethiopian restaurants bring coffee rituals from their homelands to their guests in the UK.

It's a diverse, inspirational and exciting scene – no wonder it is the birthplace of some of the world's best coffee concepts, equipment, competitions, festivals and barista champions. Competitors from the UK have brought home the World Barista Championship twice in the past decade, alongside an equal two wins each for well-known coffee countries USA and Australia. It can't be denied – the UK is the world's newest coffee darling, and London is the crowning jewel.

London Coffee tells the stories of some of the most inspirational, exciting and trailblazing individuals and companies who make up part of an ever-growing scene. It is a portrait of a place, and a time, and the people who exist in it. It is a starting point for adventure, a written record and photo album for those who have lived it, and a glimpse into the life of London.

LANI KINGSTON Writer

Lani Kingston is an Australian food writer, consultant and management professional who proudly calls London home. Her first book, *How to Make Coffee*, was an international bestseller, and has been released in five languages and eight editions. Lani holds Masters degrees in Food Studies and in Education, and pastry chef and barista qualifications. Alongside writing extensively about food, she set up London's largest bean-to-bar chocolate factory, ran a cooking school powered by 'food waste', and judges coffee for the Great Taste Awards. She is currently in New York, working with pioneering farm-to-table restaurant, Blue Hill.

DAVID POST Photographer

David Post is a Canadian photographer with an incredible back catalogue of work. David's portfolio includes work for a number of prominent London brands and his latest project, for Mast Chocolate, saw his London cityscapes printed on chocolate bar wrappers and sold worldwide. David is also a respected character in the coffee world. He owned and operated an award-winning coffee bar in his home province of Newfoundland before moving to London, where he joined the vibrant coffee scene and worked with cafés across the city.

HOXTON MINI PRESS Publisher

Hoxton Mini Press are an incredibly small (but award-winning) independent publisher based in East London. We started out a few years ago making collectable photography books just about Hackney, but, realising this could not go on forever, have now broadened out to make books about London and beyond. We believe that in the virtual world the physical book is more important than ever. Hoxton Mini Press was started by Ann and Martin, and their two dogs, Moose and Bug. Thanks for supporting us.

GLOSSARY

BREWBAR Stemming from the traditional idea of a 'bar', bartenders are replaced by baristas who – instead of handmade cocktails – offer hand-brewed coffees made from a selection of beans with a variety of brew methods. They have grown with the rise of new coffee gadgets and technology.

CASCARA The word means 'skin' or 'husk' in Spanish, and refers to the dried skins of coffee cherries, which can be brewed into teas or sodas.

COMMODITY COFFEE Coffee that is traded on the commodities market in the same way as cotton, timber or copper. The volumes in which this coffee is traded requires the produce from many different farms and, as such, coffee is often judged on its ability to meet minimum standards rather than on its unique characteristics.

CUPPING The professional method for evaluating coffee beans. The beans are brewed by uniformly steeping coffee before tasting. The SCA sets out exacting specifications, and tasters rank various qualities (such as the body, fragrance/aroma, balance, sweetness, acidity and aftertaste) out of 10, combining for a total score out of 100 on the 'sensory scale'. Cupping can be used to determine quality of a harvest, or to test how well it has been roasted – often both. A 'cupping score' is given for a particular coffee bean, with scores over 80 showing a speciality-level coffee.

DIRECT TRADE A contentious, often-misused term usually used by coffee roasters to describe buying straight from farmers, rather than through a traditional trading network. As the term is unregulated, many speciality roasters describe their own direct trade model on their websites, which often include ethical, moral, sustainable, social, environmental and fair price philosophies.

FLAVOUR PROFILE A coffee's flavour profile describes the overall taste, taking into account both inherent characteristics and processing decisions. The terroir and varietal determine one element; other flavours are instilled through fermentation and drying; and roast profiles and brewing method also contribute. Flavour profiles may be described using terms like 'fruity', 'sweet', 'clean', 'acidic', 'toasty', 'caramel' or 'nutty'.

GREEN COFFEE Beans that have been dried and are ready for export to roasters around the world. They are often a light yellow-green before they have been roasted.

PROVENANCE/TERROIR Terroir refers to the various qualities imparted by the environmental contexts in which single origin coffees are produced - whether they be from the soil, climate or farming practices. Provenance refers to the place of origin also, but usually within the context of authenticity, traceability, and customer recognition of unique characteristics attributable to a region - i.e. Champagne when it is from Champagne, France.

ROAST, LIGHT/MEDIUM/DARK The various stages to which a roaster can choose to roast their beans to. Various chemical reactions after applying heat cause the beans to turn from green to brown, continuing to darken the longer they are roasted for. Many roasters are known for their own signature roasting levels. Some roasters prefer the dark, toasty, caramel sweet flavours imparted by roasting for a longer period of time; whereas many of the newer, third-wave roasters focus on provenance; lightly roasting to pronounce the fruity and acidic flavour notes. There is a perceptible colour difference that can guide a coffee drinker in selecting beans that suit their tastes.

ROAST PROFILE Just as different cakes require different baking times (and some breads, for example, require a temperature change mid-bake), coffee roasters develop profiles based on variables to develop desired flavours in a particular coffee bean. For example, the roaster can control the heat output or airflow at various stages in the roast to develop specific flavours. Like a chef, they are imparting their own personal flair, and their 'recipe' is known as a roast profile.

ROASTERY A relatively new word, introduced into the coffee industry lexicon primarily to describe the actual location where coffee beans are roasted. It may have come about to reduce confusion, as the term 'coffee roaster' can refer to many different things: the person who roasts the coffee, a company focused on coffee roasting, and the actual machine itself.

SCA The Specialty Coffee Association, a non-profit organisation bringing together farmers, baristas and roasters. The organisation acts to unify the industry by holding events, raising standards and providing resources for all stages of the supply chain.

SINGLE ORIGIN Coffee beans sourced from a single geographical location, either from one farm or a group of farms.

SPECIALTY/SPECIALITY COFFEE Very high-quality coffees that cup over 80 on the sensory scale, regarded for their individual characteristics. They make up a component of a farmer's yield, and careful growing, harvesting and processing can increase the amount of speciality a farmer can produce. They are usually traded outside of the commodities market and, as such, very small batches can be traded, resulting in the much wider availability of differentiated, unique, single origin coffees. Many artisanal roasters only use coffee classed within the speciality bracket.

VARIETAL Originally used in winemaking to refer to the different varieties of grapes. Although a botany term, it was largely adopted by the coffee industry during the genesis of the speciality coffee movement, when coffee enthusiasts started adopting wine terms that consumers may be familiar with to show that coffee could also have provenance and terroir.

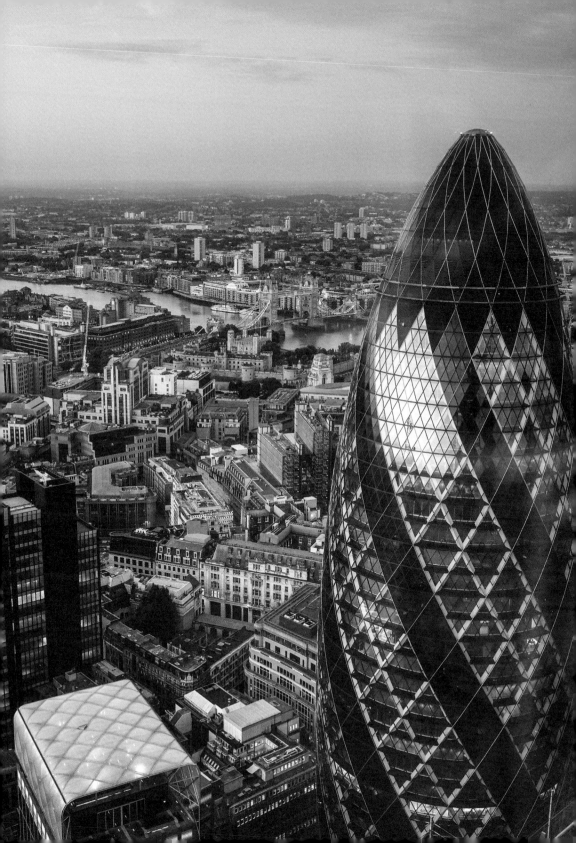

MACCHIATO
Means 'spotted' in Italian.
An espresso shot spotted
with a little milk foam.

FLAT WHITE
Antipodean-invented, double
shot espresso, steamed milk
and very little froth.

ESPRESSO
Sweet, intense shot of coffee
extracted through a high
pressure machine.

PICCOLO
Espresso or ristretto shot with
a little steamed milk and foam.
A 'shrunken, stronger latte'.

AMERICANO
Espresso shot diluted
with hot water, resembling
a filter coffee.

LATTE
Espresso, steamed milk and
froth. More milk and less
froth than a cappuccino.

CAPPUCCINO
1/3 espresso, 1/3 milk,
1/3 foam.

V60
Ceramic cone fitted with a paper filter for hand-poured drip coffee, single cup.

AEROPRESS
Steeped coffee pressed through a small filter by the top plunger for a strong brew.

COLD BREW
Coffee grounds steeped in cold water. The slow, 12+ hour extraction results in a low acid, crisp and clean brew.

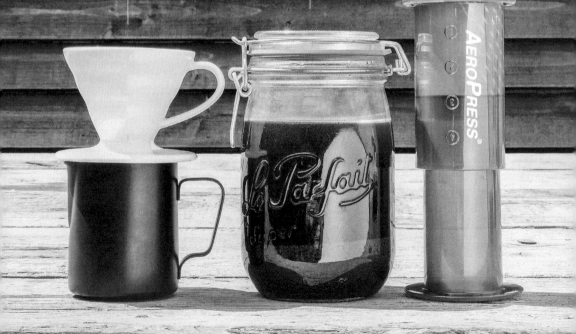

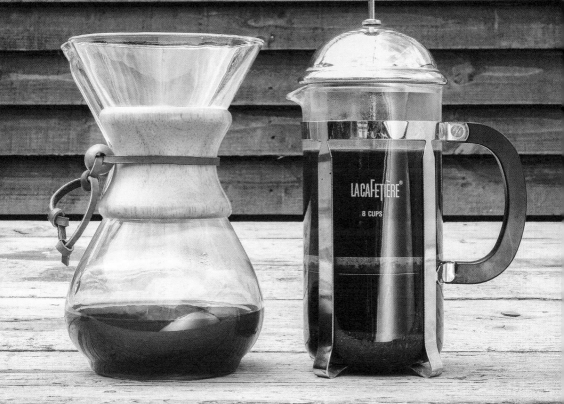

CAFETIÈRE
Steeped coffee with an easy plunger
lid to filter out the grounds.

CHEMEX
Glass flask fitted with a paper
filter for hand-poured drip
coffee, multiple cups.

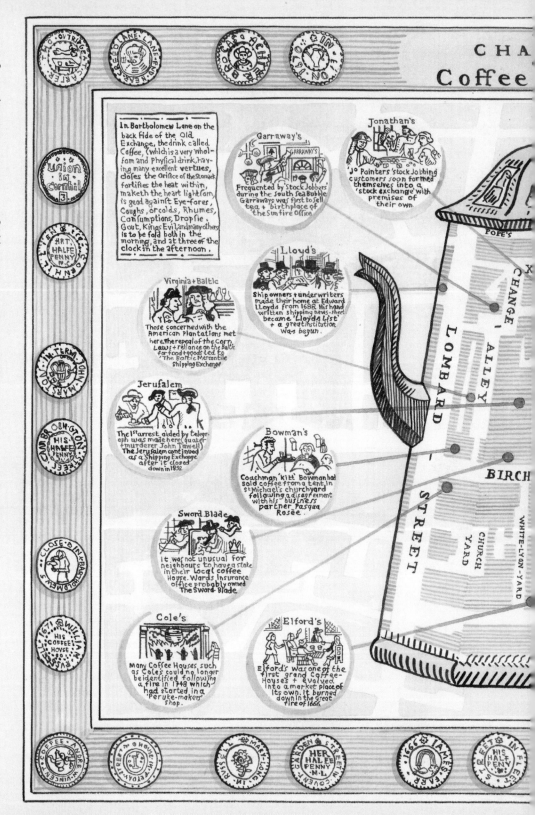

TER

ouse.

ALLEY

EXCHANGE ALLEY

ROYAL EXCHANGE

CORNHILL

ce Passage

ANE

MICHAEL'S - ALLEY

Sam's

"Monied men would find the Brokers at Sam's + ask how stocks go upon information the bidder would bid the broker buy or sell such + such."
1694 - HOUGHTON

Union

1739. Richard Shergold has his office at the Union from where he buys + sells lottery tickets in halves, quarters + eighths.

New Union

At Coffee House Auctions 'by the Candle' goods, ships, slaves etc would go to the bid which stood when a 1 inch candle had burned down

Tom's

The 1666 Great Fire focused citizens minds on questions of risk + led to companies + societies offering 'mutual protection' to subscribers via coffee houses.

Batson's

Batson's would attract quack doctors who used the coffee houses as consulting rooms + places to sell elixirs.

Rainbow

The Rainbow, like other coffee houses, issued brass, copper or gilded leather tokens, through shortage of small change.

New-York

The New York coffee house was from 1750 the centre of intelligence for all connected with the American trade.

Penfilvania

The Pennsylvania catered for shipping interests whose potential clients were found on their doorstep.

Marine

In 1719 lists were posted for subscribers to the proposed 'London Assurance' in the Marine which later becomes part of the London Assurance premises

Jamaica (Parqua Rose'es)

The first coffee house in London was opened in 1652 by 'Pasqua Rosée', a Greek servant of a 'Turkey merchant' named Edwards.

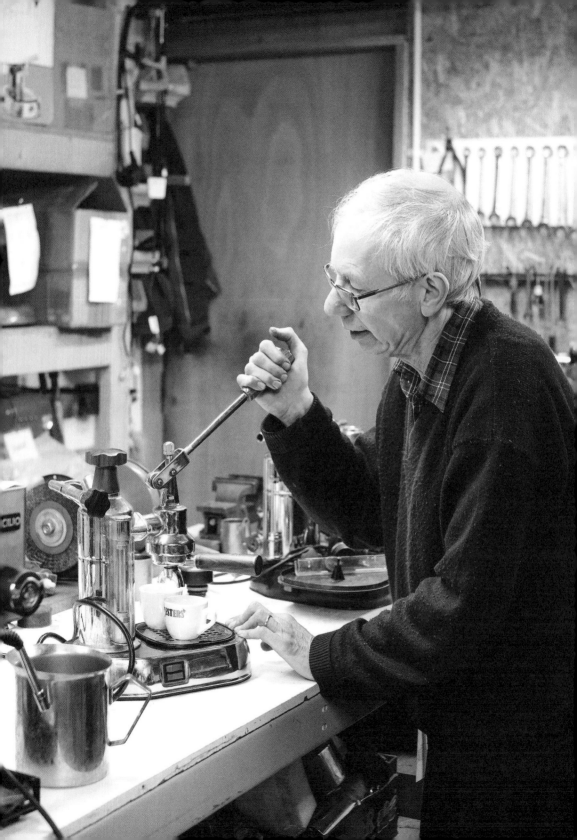

Coffee repair shop and roastery
Park Royal

AE STANTON

Trusted coffee machine repair shop keeping the caffeinated blood of the city flowing, with a small batch traditional roastery supplying since 1935.

'We often repair Pavoni machines, because they last forever. I'll ask customers who want to buy a new machine how serious they are – sometimes I'll tell them no, you are not ready for a Pavoni yet.'

Haddon Rustin, co-owner

AE Stanton is one of the oldest continuously operating coffee businesses in London, roasting constantly since 1935. These days, they are also a coffee machine repair shop, and coffee drinkers and makers travel from across the UK to visit, toting broken, whirring or jammed hand lever, espresso or even capsule machines.

Tucked away in an industrial estate in the far west of London, this small and passionate team of eclectic characters tinker away like elves in their workshop. With precision, skill and the help of a million tiny spare parts stored in brightly coloured plastic boxes, day after day they fix those machines that keep the caffeinated blood of the city dwellers flowing. With a combined half-century of experience, Haddon, Bob, Peter and Paul are part of an elite rank of coffee repairmen, trusted by those coffee aficionados that see their coffee-making ritual as an essential part of life.

The Stanton team take their machinery very seriously too. 'One customer never cleaned his machine. I told him, "You don't deserve to have a machine like this." This was six years ago, and every time he comes back he makes a point now to clean it,' Haddon laughs.

They are seeing a change in the equipment used by home coffee makers too, as the interest in speciality coffee is driving the market back to traditional machines. 'We often repair Pavoni machines, because they last forever. I'll ask customers who want to buy a new machine how serious they are – sometimes I'll tell them no, you are not ready for a Pavoni yet.'

Bob Payman, co-owner (above), Pavoni machine (right)

Address
Unit 7
Lower Place Business Centre
Steele Road
London NW10 7AT

Website
aestanton.co.uk

With precision, skill and the help of a million tiny spare parts tucked away in brightly coloured plastic boxes, day after day they fix those machines that keep the caffeinated blood of the city dwellers flowing.

25kg Probat Roaster (left), a machine known for its high quality and performance

The four spend their days fixing machinery, providing their customers with specialised coffee training, and roasting fresh coffee beans to order. The roastery supplies to cafés and restaurants across London, while their site is open to the public to buy beans for home use or have machinery repaired.

Haddon and Bob take pride in ensuring that the end cup is perfect – and not just the part they make themselves. You will often find them around the city, tasting and testing the coffee made by their customers. 'It's much better to sell to smaller businesses. We know that we will have the chance to visit and say, "What's wrong with the grind today, how old are these beans?"'

AE Stanton is a family business that has been passed down through generations. The principles and values that the company started with continue through to this day – traditional service and hospitality abounds here. Customers are on a first-name basis with the staff, espressos are handed over as soon as you walk in the door, and Haddon calls his customers daily for their order, rather than the other way around. 'Customers won't call us. But they will if we forget to call them – just to say, "why didn't you call me, what's wrong?"'

MILK

Young and vibrant neighbourhood gem serving
speciality coffee from European roasters, alongside
carefully crafted and innovative food and drink.

'We met at drama school – we were trying to become unemployed actors.'

Julian Porter, pictured with partner Lauren Johns, owners

While the London coffee scene is rife with specialist shops, roasteries and brewbars, the army of independent cafés standing behind speciality coffee brings it into the realm of the everyday; serving it alongside great food and drink in relaxed, casual environments.

Neighbourhood gems such as Milk in Balham refreshingly see their role as genial hosts. Lauren Johns, a Brit, and Australian Julian Porter make up the charming couple-duo behind the 2012-established venture; their aim was to provide 'the same environment you'd have at home – relaxing with your friends, having good food, a nice wine, a good coffee'.

'We met at drama school – we were trying to become unemployed actors,' Julian laughs. Lauren says, 'There weren't many places in London that did good coffee, good food, had good customer service and a nice environment. You get those things together so often in Melbourne, but it was hard to come by here.'

'I was 21, Lauren was 23. We didn't have any money,' Julian smiles. 'We just painted the floors and said "people will come!" We worked pretty much every day for two years.' And yet the inevitable scars from opening a café as an independent – let alone at such a young age – aren't visible on these two. They are as vivacious as they come, and excited for the future. 'We always had the idea that we would have a family of cafés,' Julian says. 'Not a carbon copy of Milk – which seems to be the way that people do things here in London – but a group of independent, unique, identities that are related.'

Their passion for good hospitality is behind everything they do. 'We wanted it to be based in those more old-fashioned values, of inclusion and wholesomeness,' Julian says. 'Everything about Milk is about being proud of what you are putting down in front of people, and being excited to share it.' This passion leads them to serve respectfully sourced ingredients in creative ways – from wolfberry and wattleseed granola to their famous organic, traditionally milled Dutch buckwheat pancakes with seasonally rotating toppings, such as sea buckthorn cream, burnt apricot, white chocolate and sweet clover, or blackberries, cajeta, corn husk and avocado leaf. Somehow they also find time to forage their herbs themselves from the banks of the River Wandle and, last but not least, they offer a robust selection of coffees.

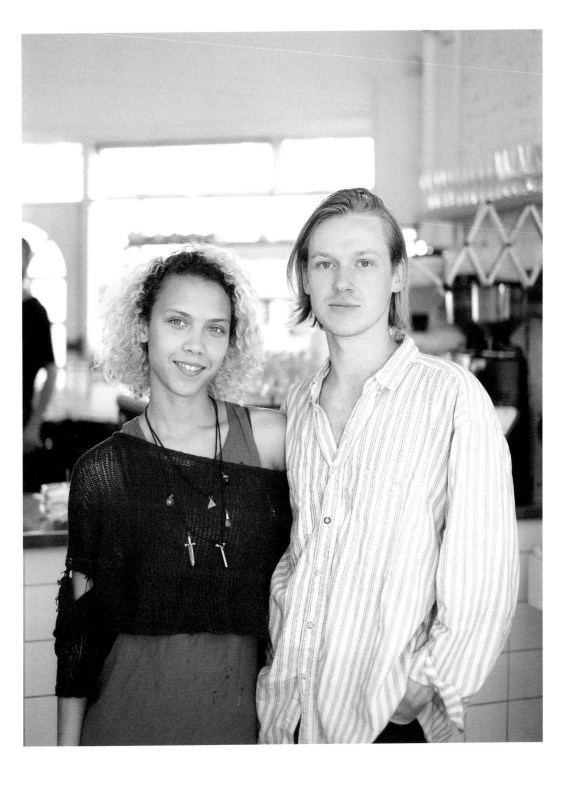

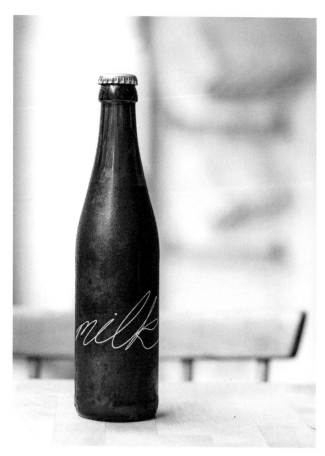

Australian-style sweet and milky iced coffee (above),
wolfberry granola (right)

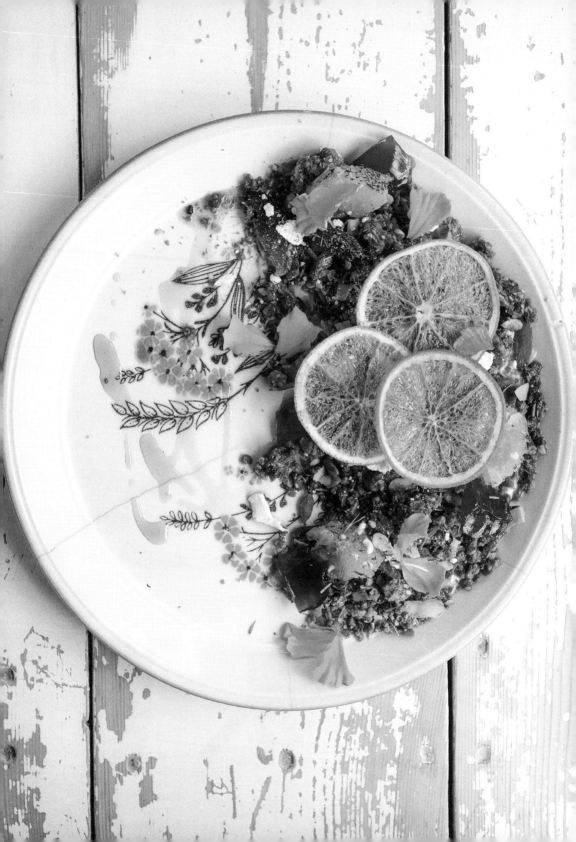

Address
20 Bedford Hill
London SW12 9RG

Website
milk.london

Follow
@milkcoffeeldn

Their espressos are from well-respected Berliners The Barn, and their filters are from Koppi, a Swedish roastery founded by barista champions Anne Lunall and Charles Nystrand.

While the UK is home to dozens of excellent coffee roasters, a well-rounded scene includes a sprinkle of diversity: Milk serve great coffees sourced from other parts of Europe. Their espressos are from well-respected Berliners The Barn, and their filters are from Koppi, a Swedish roastery founded by barista champions Anne Lunall and Charles Nystrand.

'I didn't drink coffee before, I'll be honest,' Lauren admits. 'The first filter I had was when we stayed at Anne and Charlie's house, and he made me a filter for breakfast. And I thought, fucking hell, this is amazing. There is so much flavour. I said to Jules that it was probably a heightened experience, you know, having a coffee made by a barista champion for breakfast.'

While there's certainly a focus on serving delicious coffee, the friendship and support gained through their supplier relationships is indispensable in ensuring the café is richly authentic. 'We've visited our roasters a number of times, and you really get an idea about how much of a commitment it is, and how much those people care about it,' Lauren says. 'Also, on a less tangible level, the coffees are a reflection of them as people and what they are trying to achieve. It sounds ridiculous, but the coffees feel like the people who roast them. It's our job to communicate that to our staff, and then communicate that through to the customer.'

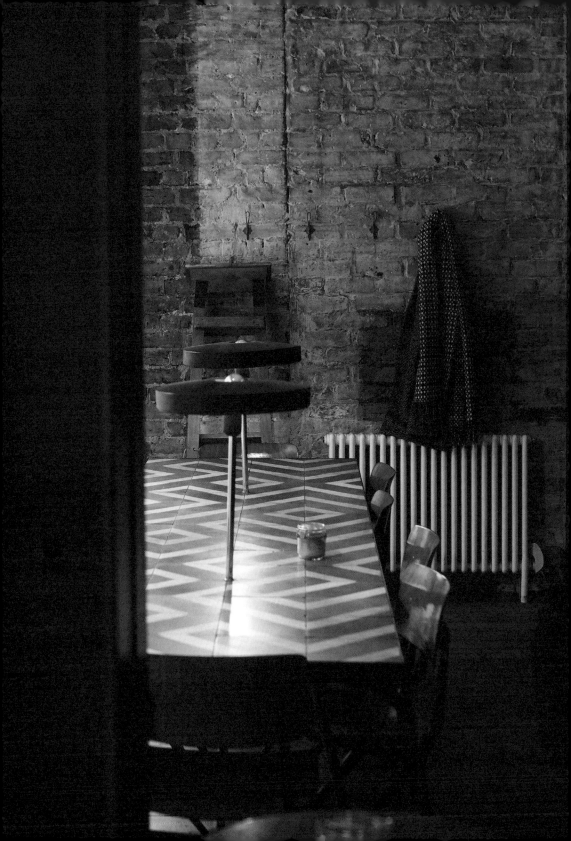

Specialist coffee bars
Leadenhall & St Paul's

ASSOCIATION COFFEE

Multi-roaster coffee specialists with a clear focus on
brewing methods and beans, located in two different
locations in the heart of the Insurance District.

'A lot of insurance people come to talk about deals here. There's a great tradition of people meeting to talk about insurance contracts in coffeehouses.'

Sam Mason, owner, pictured

Many café owners go to a lot of effort to replicate the bare brick walls, exposed steel beams and historic charm of a 'converted factory' vibe, but Association Coffee on Creechurch Lane is the real deal. Owner Sam Mason has delved into the history of the building, the area and what made London's historic coffeehouses so successful, and built a business to last.

'When we took on this space in 2012, we pulled all the plaster back and found a big steel beam and I thought – why not leave it? It speaks of what this place used to be,' Sam says. 'If you look around the walls you can see the outlines of an old furnace. Underneath, you can see where the hearthstone was, and on the other wall there is the outline of a staircase.'

Sam thinks that these marks tell the story of the former home of the West India Produce Association. Archives show that the original store had been demolished, but Sam is not so certain. 'Records suggest it was bulldozed or destroyed in the war, however, when we took out the old fit-out, we found stone plinths and floorboards that certainly predate 1911.'

The history of the West India Produce Association goes back 300 years. However, as well as being the inspiration for the name of Sam's shop, interestingly the founders of the original Association may have indeed paved the way for Sam's success today. Trading in imported goods such as tea and coffee, sugar, rum, treacle and cigars, their influence spread well beyond their grocery store's public front. Their tea was among that thrown into the harbour at the Boston Tea Party, the 1770s protest credited with starting the American Revolution. A key result of the Boston Tea Party was an American rejection of the tea culture of the British, and development of a coffee culture instead. This American preference developed into the modern coffee movement, which began in Seattle and spread throughout the world – without which we would not be enjoying third wave coffee shops like Sam's, thriving today in a serendipitous circularity all the way back on Creechurch Lane.

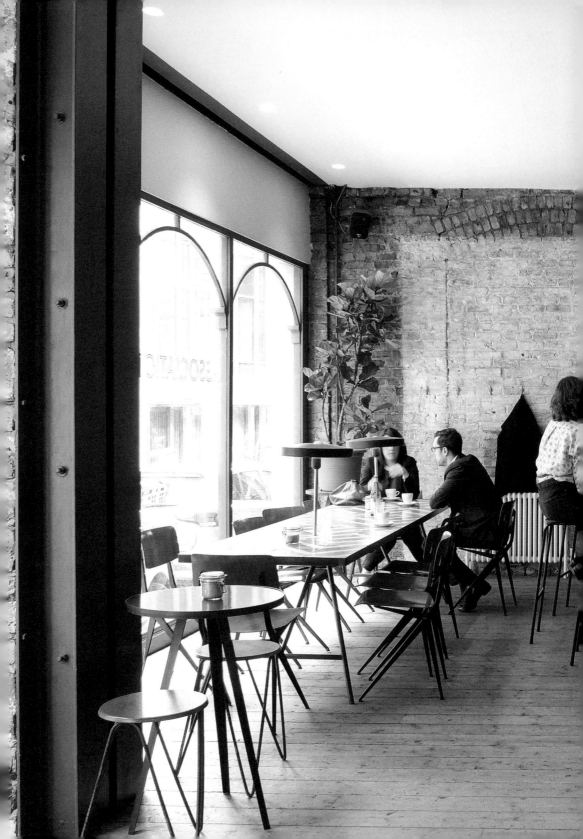

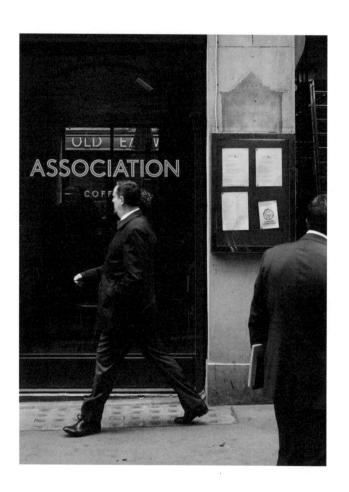

Addresses
10–12 Creechurch Lane
London EC3A 5AY

56 Ludgate Hill
London EC4M 7AW

Website
associationcoffee.com

Follow
@AssocCoffee

Association Coffee doesn't have a kitchen or offer much food; instead there is simply good coffee, made with a range of beans and brewing methods.

Located in the heart of the insurance district, Sam thinks that Association owes part of its success to being an amenable meeting place for local office workers. 'A lot of insurance people come to talk about deals here,' Sam says, 'and there's a great tradition of people meeting to talk about insurance contracts in coffeehouses.' Back in the seventeenth century, coffee shops often functioned as the original insurance firms, as they were an excellent common ground for sailors, merchants and shipowners to meet and make deals – the venerable Lloyds of London started life as a London coffeehouse in the late 1600s.

However, a modern-day insurance worker can expect a much higher quality brew here than their forebears. Sam believes in specialising and perfecting one thing – Association Coffee doesn't have a kitchen or offer much food; instead there is simply good coffee, made with a range of beans and brewing methods.

'Having a brewbar is a really important part of being a coffee shop,' Sam argues. 'If you drink copious amounts of coffee, there's a strong chance you will drink a lot of filter – if you don't have filter, you aren't catering to that customer. And that's a really important customer, because they are arguably the people for whom coffee is a really important part of their life. It's much easier to taste the origin and what the farmer has done in a filter coffee than it is in an espresso.'

While Association Coffee has expanded to a second location on Ludgate Hill, taking their historic name with them, their desire for authenticity led to a completely different style for their second store. 'To me, you need to start from scratch every time,' Sam says. 'Like a lot of the chain stores, if I've seen one I don't need to see any more. It lacks integrity when you are shoehorning a format into a space, regardless of what that space is. My hope is consumers will reward those who make the effort to do something different every time – I think it goes to the heart of authenticity.'

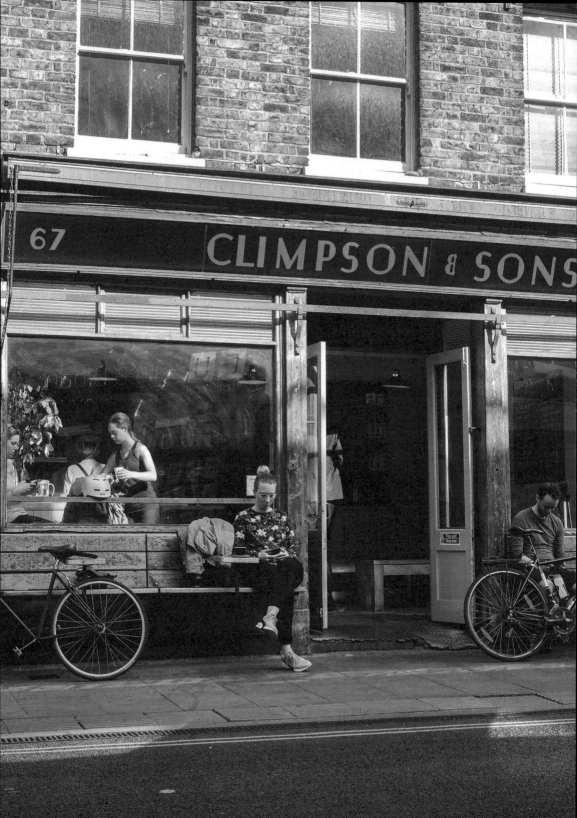

CLIMPSON & SONS

Popular Broadway Market café and London Fields railway arch roastery, focusing on light and fruity single origin beans. Served in cafés countrywide, they source unique and diverse coffee from exciting locations.

'The café has the original sign from around the 1930s – Climpson & Sons was the name of a butcher's shop.'

Danny Davies, Executive Director, pictured (left) with Dan Dunne, Head of Training

A stalwart of the East London scene, Climpson & Sons has been around in various iterations since 2002. A transient market stall until 2005, the company started their ascension to coffee industry fame when they took over their now iconic café on Broadway Market.

'The café has the original sign from around the 1930s – Climpson & Sons was the name of a butcher's shop. The name is an institution on Broadway Market, like the Cat and Mutton, the pub over the road. It doesn't change its name, no matter who goes in there. It's historical,' says Danny Davies, Climpson's Executive Director. 'We kept it and started using the name on our coffee bags from about 2007.'

Danny admits that while they have 'no Climpson, and no sons', they've created a little folklore around the name – despite the fact that relatives of the original Climpson often crop up. 'It is a name that people in East London have a connection to. People keep showing up that are somehow linked to the old days.'

On Saturdays, when Broadway Market becomes a pedestrian street market packed with food vendors and craft makers, their little

café is so busy that they've had to set up an additional street cart to help with the queues. Other days, locals soak up the sun while sipping lattes on outdoor benches, positioned to watch all manner of life go by in this busy part of East London. Climpson's offer some basic but delicious food made in-house, but people usually visit for a coffee brewed from their range of beans, which they source from all over the world and roast in their signature style.

Just a short walk from the café is their railway arch roastery. The business started mainly as a wholesale roastery and has grown from humble beginnings to one of the most well respected in the country.

'It was good being an early adopter,' Danny says. 'There weren't many micro roasteries when we started.' But as interest in coffee grows, the number of roasteries and cafés is increasing exponentially. 'It gives you the advantage having been around for so long, but you have to move with the times and the culture. What was in vogue when I started is not now,' says Dan Dunne, Head of Training. 'The coffees have changed, the way we roast has changed.'

BERLINER

COLD
BREW

COLD
BREW

ICED

ICE

ON
T

Address
67 Broadway Market
London E8 4PH

Website
climpsonandsons.com

Follow
@climpsonandsons

What is a typical Climpson's flavour profile? Dan says their beans have to be 'interesting, sweet, clean, with positive acidity and fruitiness'.

And it's this constant striving to improve and update that keeps Climpson's ahead of the game. 'We are really pushing to find new coffees. I've been working on South East Asian beans for years, and now lots of other companies are exploring them as well,' Danny states.

While they try to source from some unique origins, the beans still have to fit their brand and style. So what is a typical Climpson's flavour profile? Dan says their beans have to be 'interesting, sweet, clean, with positive acidity and fruitiness'. Focusing on lighter roasts, the team like to pronounce the flavour of origin, playing up the natural characteristics of the bean.

This focus on inherent flavour means sourcing is of utmost importance. Being more established allows the team to visit a lot of farms, and they've seen the growth of the speciality scene have a positive knock-on effect on their producers. 'Everyone is work-ing really hard to make better coffee now. Even producers lacking high-end equipment will hand-sort until everything is perfect.'

Danny says that even the farmers themselves are gaining more of an interest in speciality, due to the dramatic increase of buyers pushing for quality worldwide. 'There's so many farmer-exporters now. Often one of the farmer's children will come over here and work really hard to understand the market and get their own coffee out there. It's so cool to see.'

What's next for the Climpson's team? Rather than expand across the city as seems to be the trend, Dan says they plan to stay close to home and simply improve their knowledge, process and what they can offer customers. 'We've developed and grown with such speed, but what we are looking for is quality. As we grow, to us that just means that we can source and roast better coffee.'

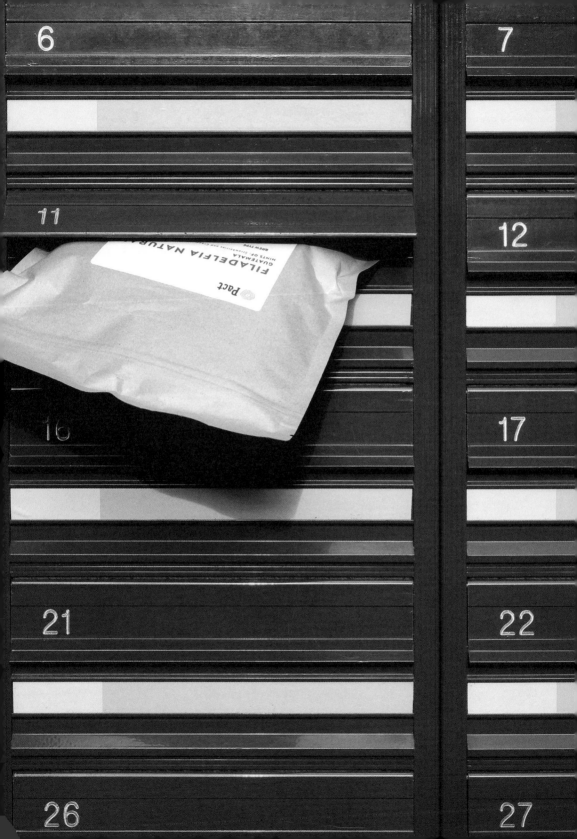

PACT

Subscription coffee roasters forging a path into the future for speciality coffee, combining sustainable, ethical business with innovative and custom technology to bring good coffee to more people.

'This year, we will sell 250 tonnes of coffee in the UK. And that's not 250 tonnes that was being sold to a different roaster, it's 250 tonnes of new speciality business that's being bought at a higher price, paid directly to origin.'

Will Corby, Head of Coffee, pictured

Research has shown that over half of this great nation's coffee drinkers prefer to drink at home, proving that while the streets are lined with stylish places to while away an hour or two, there's still a huge demand for quality coffee for the home market too.

As interest in coffee has widened to single origins, brewing methods and varietals, and grown to a feverish pitch, consumers have come to expect a level of quality across the board. But often this was difficult – sometimes impossible – to find at your local store.

'Pact started in 2012 with the aim of making amazing speciality coffee really easy for people to get their hands on,' says Will Corby, Head of Coffee. 'While it might have seemed that it was readily available, it was really only in small pockets of London. If you moved outside of London, it was almost impossible.'

So founder Stephen Rapoport set about solving this. Using his tech background, he decided the way would be to build an online subscription company for speciality coffee. But Pact isn't just any old subscription service, it's an entirely unique model, and provides an insight into how craftsmanship, quality and technological advancement can come together and guide the industry into the future. Pairing our perpetual desire for convenience with the modern desire for craft, Pact uses complex, in-house designed technology to efficiently prepare up to 5,000 individual, customised orders per day.

So what sort of coffee does Pact sell, exactly? Well, the flexibility of their technology means pretty much whatever a customer wants. 'To start, we created a range of four flavour profiles that could be fulfilled by coffee from pretty much anywhere in the world, so long as the balance and flavour notes hit the right boxes. When one type of coffee runs out, another with similar characteristics replaces it. We work with 148 farmers worldwide, so that leads us to change over our coffees sometimes twice a week,' explains Will. 'We'll first ask new customers what their preferred flavour profile and brewing method is, which gives us a clue what people will like.'

Using the collected information, the Pact website (and the innovative technology behind it) gives subscribers an array of options. 'Customers then tell us how much coffee they drink. So, if they drink one a day, the system will arrange for one bag every two weeks. If they say they use an AeroPress, our system offers two suitable coffees to pick from. Our system would then send a similar coffee every time.'

'We ship up to 11 different coffees on one day but we also send four different grind sizes and whole bean. So that's 55 different things potentially going out the door.' And on top of this, all coffee is roasted just one day before it's shipped out.

Pact isn't just any old subscription service – it's an entirely unique model, and provides an insight into how craftsmanship, quality and technological advancement can guide the industry into the future.

Their flexible technology is what makes this otherwise monumental endeavour possible. Pact staff work in tandem with a seriously clever computer program which gathers, analyses and distributes appropriate data to each area of the business, enabling a smooth transition through ordering, roasting, packing and shipping. While the backbone is hi-tech, all coffee is still roasted by actual people in traditional roasters, who fill each bag by hand.

'Technology can have a positive impact,' Will says. 'We import so much coffee, directly, and almost all of that is new speciality coffee to the market. This year, we will sell 250 tonnes of coffee in the UK. And that's not 250 tonnes that was being sold to a different roaster, it's 250 tonnes of new speciality business that's being bought at a higher price, paid directly to origin. Technology has allowed us to do this really efficiently which helps to keep the costs down, and introduce amazing-tasting coffee to people at home.'

'For a business that's growing fast the way a technology company does – it's down to finding new producers to fulfil that. And if we want to make coffee that's a force for good, then how do we do that? We utilise our growth to help bring more farmers to speciality.'

Pact's size allows them to assist farmers to make changes to their methods or systems to increase the quality of their coffee. Because a farmer could lose their livelihood if the crop turns out badly, buyers recommending changes to a farmer's methods are often regarded with caution. Pact counteracts this by guaranteeing they will buy the harvest no matter what.

'It's one of the things that gives me sleepless nights,' Will says. 'We paid for flotation tanks for 13 farmers last year, and they ended up producing a whole container of coffee. From a risk perspective, it was low – we had worked with an agronomist, we knew it would have a positive impact – but still, a container of coffee costs USD150,000 – that's a lot of money if something goes wrong. That's more than anybody earns!'

But it's taking these risks that is resulting in immense positive outcomes back on the farms. Their last project saw a drastic increase in quality – one farmer saw a 10-point increase in his cupping score, which results in a much higher price paid.

'I've worked for coffee importers in the past, so I know what people pay for speciality coffee, and we pay really good prices,' Will explains. 'Along with that, when we ship every bag of coffee, we include a card which credits the farmers. Most of the producers are used to selling their coffee at a local co-operative. No one will ever know who the individual is who has put all that hard work and labour into it. Most of them live on the farm all year round. Life is tough there. They are slogging away for those ten sacks of coffee. And people forget that. Having that card go out – yes, it's for the customers to relate to them, but it's also for the farmers to see that someone's printed their name and the name of their farm 2,000 times; that's what they really love. The name Pact is about a pact, a relationship and a promise – a promise to connect the producers we work with to the consumers that drink their coffee.'

THE ESTATE DAIRY

Ex-barista and dairy farming pair provide scientifically analysed, free-range 'barista milk' to London cafés, sticking to the philosophy that speciality coffee deserves speciality milk.

'We wanted to close the gap between the barista and the dairy farmer.'

Shaun Young, pictured with Rebecca Young, founders

'Eighty per cent of the coffee served in cafés is milk-based,' says Shaun, one of the two young founders of The Estate Dairy, 'so we wanted to provide a milk that was the same quality as the coffee being served.' After working in London's coffee industry, Shaun and his business partner Rebecca recognised a need for a high quality 'barista milk'.

'People care about where their product comes from. Same as the coffee itself: everything that is sourced has to contain some element of traceability. We wanted to close the gap between the barista and the dairy farmer.'

Shaun and Rebecca started The Estate Dairy in 2015 to do just that, by sourcing high quality, single herd milk that met their exacting specifications for use in coffee. Working with the head of research at the Speciality Coffee Association of Europe, they discovered that a high concentration of protein is key for foam stability. Secondly, fat content: 'We needed a milk that was rich, but not too dense.' They discovered only two varieties of cow – Jersey and Guernsey – could naturally produce milk that met these requirements.

After a needle-in-a-haystack search across the UK, they found the perfect milk. Then, after packaging it up and selling it back in London, they found themselves turning away new accounts just three months after opening.

So while it's clear that consumers love it, the farmers love it too. 'There's a lot of high quality milk that's not being appreciated by the person who is buying it. The Guernsey farmers we work with used to sell their milk to a large cheesemaker. It would be blended with milk from 40 other farms, which is like blending coffee from 15 different origins. You are going to lose the characteristics of what makes it good.'

The Guernsey herd at Bickfield Farm, Bristol

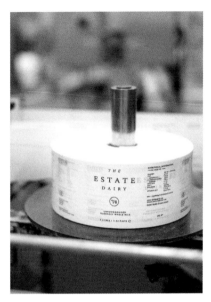

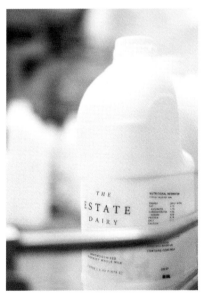

Website
theestatedairy.com

Follow
@theestatedairy

Pioneering studies into flavour, aroma and chemical make-up, they work with researchers to determine how feed can change the taste of the milk – and then ask London's best baristas what they prefer.

The Estate Dairy are certainly masters of working out exactly 'what makes it good'. Pioneering studies into flavour, aroma and chemical make-up, they work with researchers to determine how feed can change the taste of the milk – and then ask London's best baristas what they prefer. This opening of communication channels between barista and farmer ensures constant product improvement and transparency, and results in higher levels of satisfaction of both farmer and customer.

The Estate Dairy aims to change what they call an 'old-fashioned industry'. They pay their farmers almost 50 per cent more than the average milk price by cutting out multiple tiers of middlemen. They only work with farms that operate a free-range dairy philosophy and pioneer traditional dairy practices, and they refuse to take on more accounts if it will put stress on the farm's output. By generating barista interest in high-quality milk, they are increasing customers' expectations and making them think about what goes into their coffee.

'The cost of production of a litre of milk is actually higher than the average commercial price. Most farms are tied into a volume contract though, so when prices go down, they have no choice but to supply at a loss. Dairy has to change. The more companies that operate as we do, the better.'

MERCANTA

Pioneering green bean 'hunters', who introduced speciality coffee trading to London and provided the backbone for the current coffee movement. Sourcing and providing speciality coffee to top roasters since 1996.

> **'I find it very satisfying to see coffee we have sourced - often from very remote and isolated farms - at its destination.'**

Stephen Hurst, founder, pictured

In 1985, a young logistics trainee named Stephen Hurst was hired by J. Aron & Co, a trading arm of the Goldman Sachs Group specialising in commodities such as precious metals and coffee. Little was he, or anyone else, to know that this was to drastically change the coffee industry in London and beyond over the following 30 years.

After a year at J. Aron & Co, Stephen got an offer to train on the coffee trading desk. By the late 1980s, he had become the Executive Director of Coffee Trading, and oversaw major European roasting companies, Central and South American sourcing, and often visited the farmers directly. Then, coffee was usually traded on the commodity market in immense quantities, but it was the smaller US roasters operating on the periphery that piqued Stephen's interest.

'They were approaching a giant trading company like J. Aron for 50 bags of this, 20 bags of that. Artisan roasters (who really wanted genuine top quality beans) contacted our New York office for beans from Rwanda, Costa Rica and Kenya, which we had, but typically only in commodity-sized containers and qualities.'

Stephen realised that this was the beginning of something. Before it even had a name, he recognised that the speciality coffee movement was stirring. 'I had a strong feeling that the model would not be confined only to North America. Everything tends to be about timing, and I find it telling to consider when the different regions' Specialty Coffee Associations were formed. In North America, the SCAA was founded in 1982; in Europe the SCAE was founded in 1998, and the SCAJ – Japan – in 2003. The formation of these associations speaks of the first inkling of recognition of the new quality-driven sphere.'

A couple of years before the European association was founded, Stephen started his foray into speciality green bean trading in London. Using his knowledge of large-scale commodity coffee trading, his connections with farmers, and his knowledge of what the US artisan roasters were looking for, he branched out and set up Mercanta in 1996 to bridge the gap between farmers in producing countries and those roasters who were looking for high quality beans, often in low volumes.

At that point, there were very few roasters interested (in fact, there were very few roasters in the UK at all), which made the first few years a struggle. But Stephen was certain he was on the right track. 'I saw things moving in the direction of differentiated, genuinely higher quality, raw beans. I realised Mercanta had to be about added value, whether it be expertise in sourcing, risk management, access to lesser known areas, fieldwork and quality discovery, setting up of origin sourcing offices – it could not simply be buying raw beans in one place and selling them in another. The whole concept of Mercanta was built from the word merchant. A conscious and important distinction from broker, agent, intermediary, conduit, third party.'

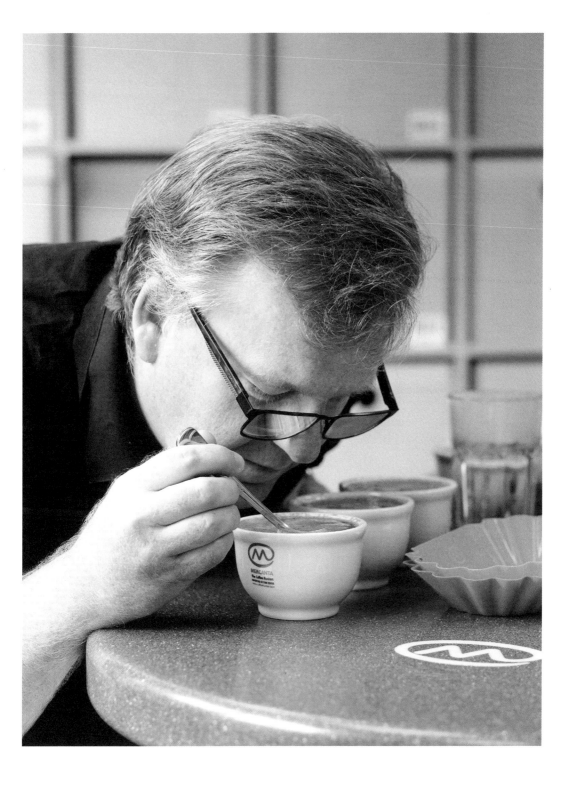

Fast forward 20-odd years, and Mercanta has grown exponentially from the early days when it was based out of Stephen's home. Its contribution to the development of London's coffee scene is incalculable. Without access to quality green coffee, the speciality scene could not have grown.

Although most roasters were working with commodity beans at that time, Stephen found a kindred spirit in Anita Le Roy of Monmouth Coffee Company. She had been searching, largely in vain, for quality green coffee to supply her 1978-founded Covent Garden speciality roasting business. Prior to Mercanta, Anita says that when she asked about coffee from specific origins, she was often told 'it's all the same anyway'. Stephen's arrival on the scene filled this missing link in the supply chain, allowing small roasteries to access quality, differentiated coffees. 'He knew farmers, so he had the genius idea at that point to bring single farm coffees into the UK. That was the first glimmer of hope and light,' Anita says.

Fast forward 20-odd years, and Mercanta has grown exponentially from the early days when it was based out of Stephen's home. Its contribution to the development of London's coffee scene is incalculable. Without access to quality green coffee, the speciality scene could not have grown.

'We move a premium agricultural product from thousands of interior, inaccessible locations to real physical coffee roasting businesses in more than 40 countries,' Stephen explains. In addition, his contribution to furthering the industry spreads out beyond green beans: he founded the London School of Coffee in 2004, which provides coffee education to the home enthusiast and professional alike.

Stephen has now rolled out his model across the world, helping build fledgling speciality movements globally. Mercanta provides access to coffee for the big and the small, in any location, increasing access to quality coffee for the roaster – and therefore the consumer – worldwide. 'We have delivered specialty coffee to the Faroe Islands, to parts of Norway inside the Arctic Circle, to Kazakhstan, to the Maldives. But,' he says, 'London, our home turf, has to be one of the biggest success stories. London is now not only on the specialty coffee map, it is very nearly the epicentre of it. From a handful of decent cafés, you now have hundreds.'

'I find it very satisfying to see coffee we have sourced – often from very remote and isolated farms – at its destination,' Stephen says. 'As we manage the entire farm-to-roastery chain, it is very rewarding to see a coffee from, for example, Jardin, Colombia at a roastery in Singapore, Seattle or Shoreditch.'

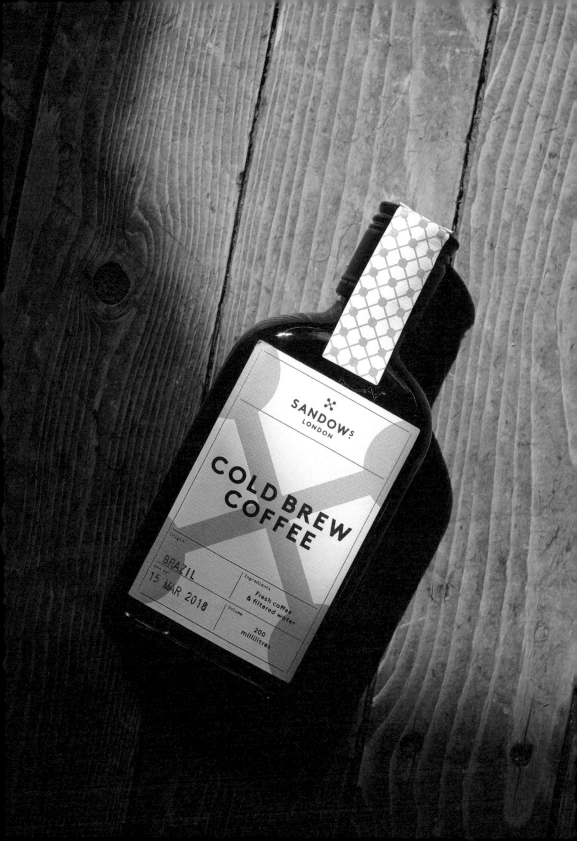

Cold brew coffee company
London Fields

SANDOWS LONDON

Two Hackney brothers-in-arms, spreading the word about smooth, crisp, cold brew coffee. Sold in nitro cans, trendy hip flasks and on tap countrywide.

'We are getting to the point where people don't want to pay £3 for one coffee, but they now have the expectation of quality.'

Hugh Duffie, pictured (left) with Luke Evans, co-founders

'I didn't even drink coffee until I moved from Australia to London. I used to order a chocolate milkshake when I went to cafés,' laughs Hugh Duffie. Arriving in London just as the city's interest in coffee rose to the point of obsession, it didn't take him long to get hooked.

'Everyone goes through a journey with whatever they are into. Beer is a good example. You start off with the cheap stuff, and as you develop a taste for it, you start to think, what is this craft beer stuff? After some time, you just want to return to something simple, something smashable. It's a bit like that with coffee. We are getting to the point where people don't want to pay £3 for one coffee, but they now have the expectation of quality. They just want something a little more everyday. That's what we are aiming for.'

Hugh Duffie and Luke Evans, the two brothers-in-arms behind Sandows, want to 'democratise good coffee'. Since 2012, they

have been championing good, simple flavours by selling hip flasks of cold brew to design-savvy consumers countrywide. The cold brew method of brewing coffee – a long, slow steep of coarsely ground coffee beans, with no heat applied – extracts crisp, clean flavours. The acidity level is low, because certain oils and fatty acids are only released at high temperatures. Now, after gaining a legion of fans and high-end stockists, they are taking it up a notch with their nitro cans. Their signature cold brew is supercharged with nitrogen that froths, foams and cascades like Irish stout.

While it can take a few tries for your average coffee drinker to develop a taste for cold brew, due to the different and unique flavour profile, Hugh says their nitro version is an all-round crowd-pleaser. 'We all love sweet stuff. Nitro cold brew is a lot sweeter because of the nitrogen – everyone thinks it has milk in it.'

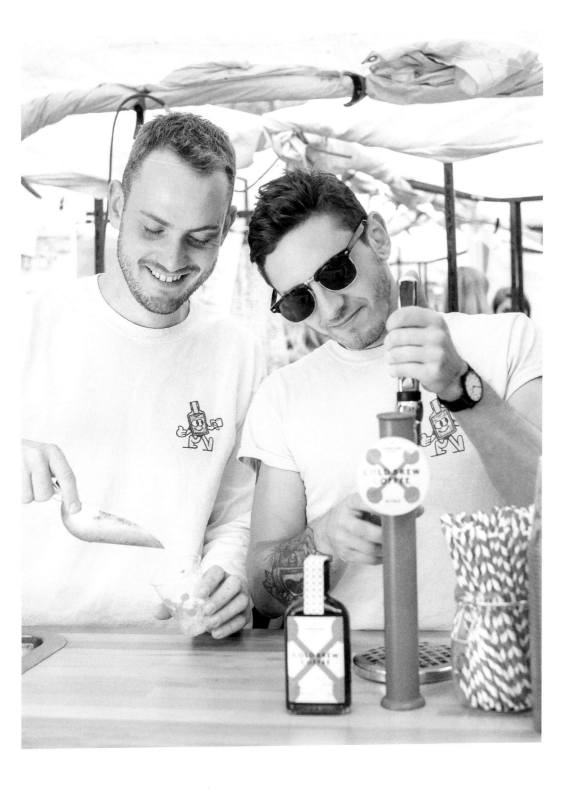

Website
sandows.com

Follow
@sandows

The cold brew method of brewing coffee – a long, slow steep of coarsely ground coffee beans, with no heat applied – extracts crisp, clean flavours.

Their hip flasks of original cold brew are available in places like Whole Foods, Sourced Market and Soho House, and you can also find their nitro version on tap throughout the city at places like the Ace Hotel, Crosstown Doughnuts and Grind Coffee. While all versions are ready to drink, they can be paired with milk, sugar – or booze. Sandows have developed a cult bartender following, with leading cocktail bars using their cold brew in various concoctions. While their original flavour takes the stage, special flavours can sometimes pop-up – from nitro chai to cold brew gin and tonics – so it's worth keeping an eye on their Instagram for new local stockists.

The aim is for Sandows' cold brew coffee to be an everyman's drink. While it is available on tap in cafés throughout the city, in East London's Netil Market on Saturday mornings, and in upmarket department stores, Hugh wants it within reach for an impromptu summer picnic or when picking up a grocery store sandwich for lunch on the run. 'We have realised that while it's awesome to be stocked in Selfridges and Fortnum & Mason – and I'm really proud of that – we don't shop there. We want to make it possible for people like us to buy our product too. It seemed crazy to not have it in places where people like us actually go.'

There's something special about a coffee scene that fosters such innovation and experimentation, and yet sees a level of craft infiltrate into everyday life. 'A lot of people say the coffee in Melbourne or Portland is the best in the world, but I disagree. The thing about London is that about eight or nine years ago it had such an influx of experience come in. They always say that your second business will be the most successful, because you've learnt all of the lessons from the first. The fact that we had all these experienced people come on to the scene, combined with the audience here having unbelievably high standards, makes it an exciting place to be. I'd happily say the coffee in London is the best in the world.'

Multi-roaster coffee bars
Marylebone & Leadenhall

CURATORS COFFEE

Two bright, modern, Central London coffee shops,
curating thoughtful galleries of art, coffee beans
and brewing methods.

'There are a lot of Australians and New Zealanders here who have come from such strong coffee cultures – they realised there was a hole in the market here.'

Catherine Seay, co-founder, pictured previously

Tucked away behind London's perpetually busy Oxford Street, the crisp, clean lines of Curators Coffee Gallery reveals an attention to detail that is applied all the way from the seating to the coffee beans.

Catherine Seay, the bright and bubbly face of Curators, was just 25 when she and her co-founders opened the first store, Curators Coffee Studio, on Cullum Street in 2012. Their second store, Curators Coffee Gallery, opened on Margaret Street in 2014. The shops double as art galleries, but the 'curator' part of the name doesn't just apply to the exhibitions: they gather a range of high-end coffee under one roof, selling a curated selection of beans from different roasteries.

'We were lucky enough to find a large space where the concept of a brewbar would work very well,' Catherine says. 'Curating beans is something that we can do as we aren't a roastery ourselves. From day one, I wanted to have our house espresso, a grinder that was dedicated to serving guest espresso, and a range of different filter coffees. It's a great way to be able to have loads of different beans from different roasteries.'

The baristas at Curators are able to do all of these beans justice too, as they can recommend the best brewing method to pair with a particular bean. Another reason to visit are the 'signature drinks' – a concept common in barista competitions where competitors infuse a drink with their own personality, but unusual to see available to the public. Curators have been known to serve drinks such as spiced lattes and sparkling cascara with lime, depending on the season.

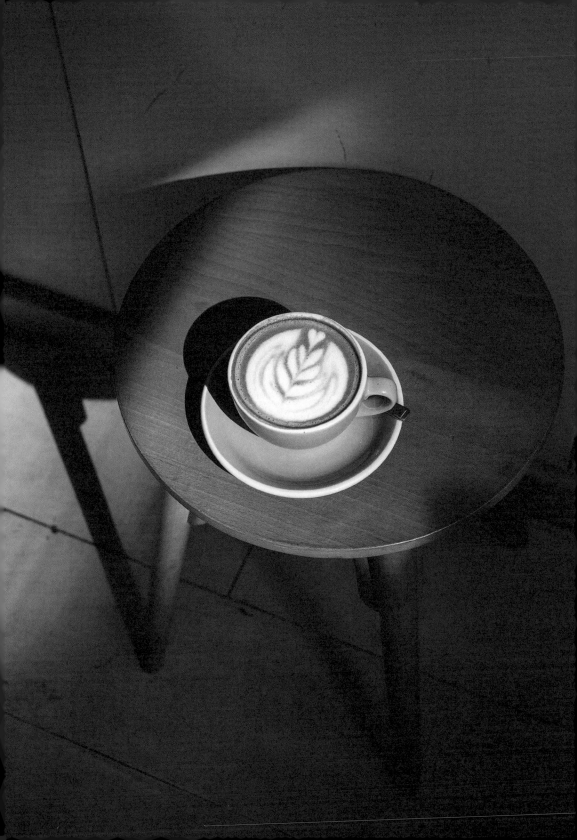

Addresses
Coffee Gallery
51 Margaret Street
London W1W 8SG

Coffee Studio
9A Cullum Street
London EC3M 7JJ

Website
curatorscoffee.com

Follow
@curators_coffee

Curators have been known to serve unique drinks such as spiced lattes and sparkling cascara with lime, depending on the season.

Catherine has the knowledge and background to ensure she is able to curate a winning selection. Arriving in London from Australia in 2009, she started working in speciality coffee and never stopped. 'When I first arrived, I applied for a job that advertised as at an 'Australian-style café'. I thought, "I'm Australian, I can do that!" It ended up being Kaffeine, which was just opening. I was one of the original team members and worked there for two years. The London scene was just emerging so it was quite exciting.'

Catherine believes that expats and the diversity of London have had a large influence on the speciality coffee scene. 'There are a lot of Australians and New Zealanders here who have come from such strong coffee cultures – they realised there was a hole in the market here. There were certainly influences from Scandinavia and the USA, but if you think back to the speciality cafés that first opened in London, a lot of them seemed to have a link to Australia or New Zealand.'

'The other main influence was James Hoffman [of Square Mile] – he has a worldwide presence. He was paving the way for speciality coffee here, and supplying it. You could open a coffee shop, but if you don't have a supply of great speciality coffee, what's the point? Square Mile were providing that.'

As time goes on, the number of speciality coffee roasteries is growing exponentially, meaning Curators gain a never-ending base of beans to draw from. Alongside their seemingly limitless combinations of beans and brewing methods, they also serve fresh food, cakes, house-made granola, and provide a light-filled space behind Oxford Circus to while away an hour or two.

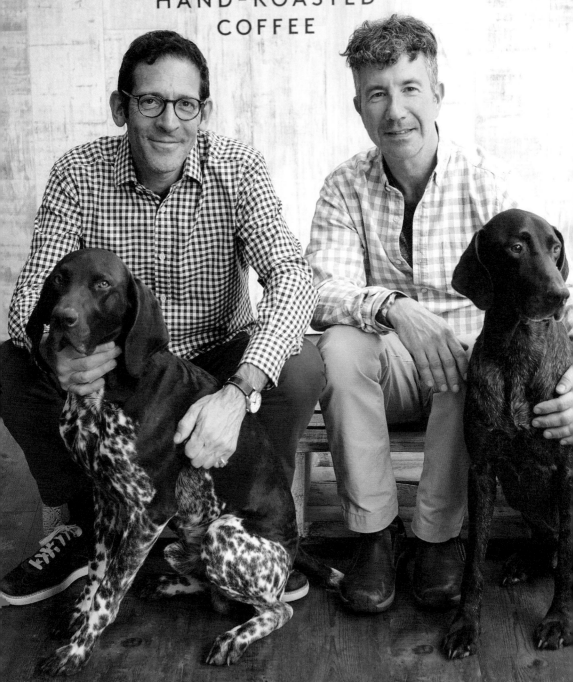

Speciality coffee roastery
Poplar

UNION HAND-ROASTED COFFEE

Established coffee roasters with a unique and
responsible trading philosophy, bringing speciality
coffee to a wider audience by offering high
quality coffee for brewing and drinking at home.

'We always hoped to be able to buy coffee by visiting farms; much like winemakers - they know where their grapes come from.'

Jeremy Torz, pictured previously (left) with Steven Macatonia, founders

Returning from a work placement in California in the mid-1990s, Jeremy Torz and Steven Macatonia brought back more than just a few souvenirs. In San Francisco they'd gained a newfound love and appreciation for good wine, coffee, cheese and bread.

'In the early nineties, the food and drink scene in the Bay Area was kicking off,' Jeremy says. 'We started asking, why is this coffee so damn good? We started to network into what was a very small but bubbling up coffee scene. We became aware that there was more to great coffee. It became a consuming interest.'

They realised that the exciting and burgeoning scene in the US had not yet hit the UK. 'So we sold everything that we had and rented a little shed on the outskirts of Essex, bought a roasting machine, and managed to find some decent quality green coffee. We spent six months locked away burning and learning, and then we eventually started to sell to cafés.'

Their first coffee roasting business opened in late 1994, and a few years later merged with the then-small Seattle Coffee Company, credited with introducing the second-wave coffee shop to the UK. In 1998, Starbucks decided that the UK market indeed had potential, and, upon acquiring Seattle Coffee Company, took Jeremy and Steven along for the ride.

'It was a phenomenal journey – terrifying and exhilarating at the same time,' Steven says. 'We were the coffee knowledge part of Seattle Coffee Company. It was the first time people had been introduced to a latte; it was about explaining the language of coffee. The flavours, the tastes – the way we were roasting was so much darker compared to what the UK consumer had before, but that brought out that depth, that sweetness. The response was always "Wow! I didn't know coffee tasted like this!" and it was fantastic to get that reaction.'

'It quite quickly took off,' Jeremy adds. 'You look around today, and where don't you see people walking down the street enjoying a coffee? It was in our original business plan – will British people walk and drink in the street? It wasn't considered polite in British society. You eat at the table!'

They only stayed on with Starbucks for just over a year, but Steven says, 'It was great opportunity to see how the grown-ups did it. But we realised it wasn't for us, we wanted to be in charge of our own destiny. So we left. We went back to bootstrap startup, but we knew what we needed wasn't just a small shed business. So it was a different founding vision for Union.' They started their new roasting business, aiming to change the way coffee is both traded and consumed, and are now one of the largest speciality suppliers for the home market – they are accessibly stocked in supermarkets and delis UK-wide, and operate a successful subscription and e-commerce business too.

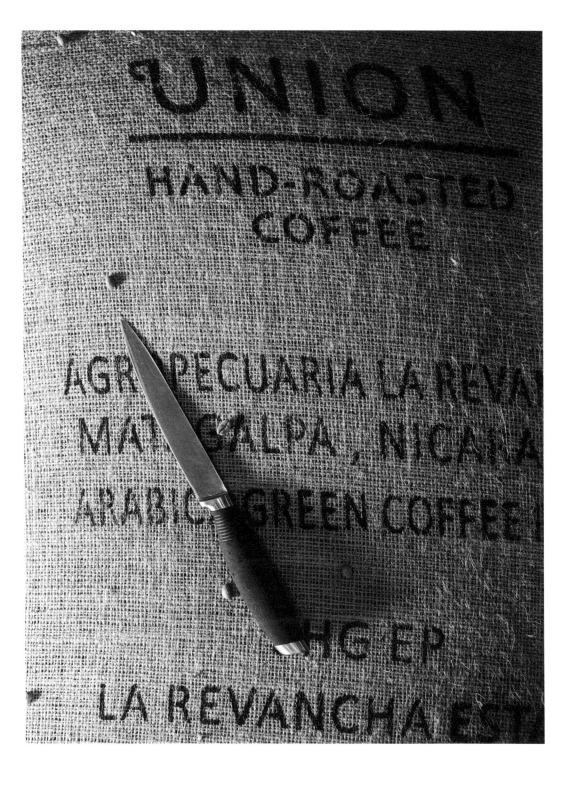

The term 'direct trade' is fairly undefined and therefore often misused, but it's usually taken to mean simply a direct connection between roasters and farmers. Jeremy stresses that there are a number of facets in any trading situation, and any 'direct trade' model should encompass a number of different philosophies, spanning from price paid to ethical trade. Union did their research before launching, ensuring they were operating in a way that they could 'look over our shoulders and be comfortable about'.

'We always hoped to be able to buy coffee by visiting farms; much like winemakers – they know where their grapes come from,' Jeremy says. 'But the coffee trade has always been somewhat anonymous. After Starbucks, we went out to Central America and started to have a look at coffee farms. The market was on the floor, price wise. Families were losing their land; they weren't able to farm sustainably, and farms were being abandoned, repossessed. We thought, this is wrong – this is broken. So we started to tease out ideas for what our role or responsibility as a roaster could be.'

Using their extensive experience and understanding of all facets of coffee, through all stages of the supply chain, they've developed a model they call 'Union Direct Trade'. It's an all-inclusive, sustainable and ethical way of doing business that invests in long-term relationships.

'It's not just about agreeing a price with a farmer that works for them, because many farmers don't even have the capability to produce coffee to export status,' Steven says. 'The key to it is that we act as buyer, but also as willing financier and, most importantly, mentor,' Jeremy adds. 'A lot of people say we can do it because we are a big company, but that's not true, we've done it since day one. It just grows with us. The use of the term "direct trade" exasperates us – it doesn't mean cutting out the middleman, or taking their margin, but it means working to understand the supply chain. When we started Union, there was just four of us, but we were overseas 16 to 18 weeks a year, building those relationships. Anybody can do it.'

At the heart of these long-term relationships is a commitment from Union's side to both help the farmer increase quality, production and working standards, and also to ensure they have a certainty of income while they do so. Steven and Jeremy have worked closely with Dr Aaron Davis from the Kew coffee research team to offer a chance for some of the coffees from sustainability projects to come to market.

But while Jeremy and Steven are heavily involved in environmental and economical sustainability projects, they often need to remind themselves they are a small commercial business, not an NGO. Although back in London, their inspiring work certainly leads to benefits for the consumer as well – whether it is all-round higher quality coffee, or the chance to drink exclusive, rare coffees that would not otherwise have come to market.

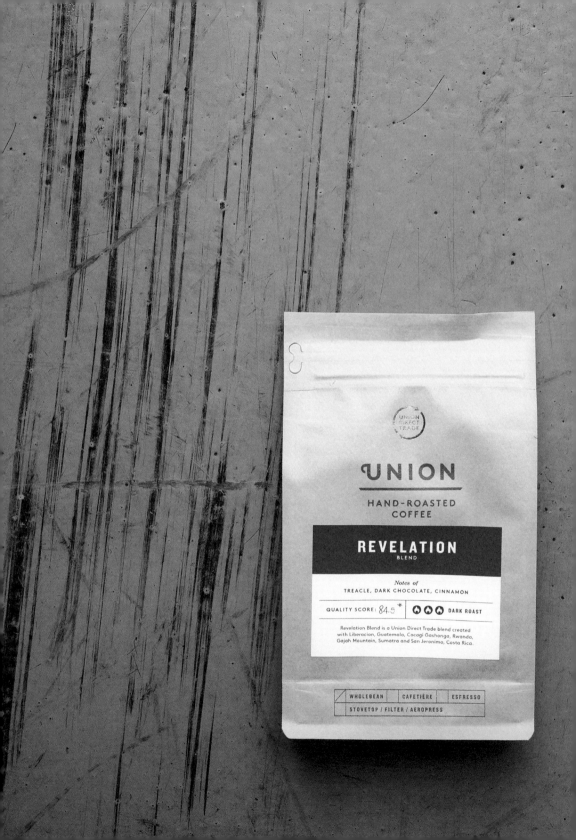

Website
unionroasted.com

Follow
@unionroasted

Whole bean or ground, from a variety of origins or blended: no matter the style, a Union coffee assures not only ethical and sustainable supply chains, but also a speciality cupping score.

'We pay for this. It's all done out of our own cash flow. Why should the consumer have to make a value choice? Why should you have to choose between something that may not taste as good but it has a charity badge on it, or a better coffee that you're not so sure about the ethics of? That should come together, and that's what we want Union to be for.'

As well as challenging the norms in coffee trading, Union is also pushing back on the quality side as well. While often seen as big business in the London coffee world, Steven assures that Union don't have an ambition to grow for the sake of it: 'The biggest pressure on us to grow is when we've had a great meeting with the co-op, and they are going to produce an extra 36 tonnes next year – how can we find a home for that? We want to see them succeed, so we have to grow our market here.'

One way to get quality coffees out to a larger audience is by partnering with leading supermarkets and getting Union's coffees on the shelves next to the familiar supermarket brands. It's perhaps the first time that a speciality coffee brand in the UK has packaged up high-quality coffee to appeal to the convenience-led general supermarket coffee buyer, without compromise. Whole bean or ground, from a variety of origins or blended: no matter the style, a Union coffee assures not only

ethical and sustainable supply chains, but also a speciality cupping score. They don't sell coffee that scores under 84 on the Specialty Coffee Association sensory scale – classing all of their coffees well into the speciality bracket. In fact, they are so honest about the quality of their beans, they've chosen to print the cupping score right there on the bags.

'We've always pushed the boundary, wanting to encourage conversation,' Jeremy says. 'The thing about the quality score on the bag is that we don't necessarily expect everyone to understand it, but when you see a supermarket grade coffee selling a bag at almost the same price as a premium coffee, you think, come on! No wonder customers are confused! So we put it out there as a dare – if they think their coffee is worth the same price as ours, then they should tell people honestly about what the quality is. So we thought we'd put the quality score out there and see who joins the party. It's been 18 months and nobody has stepped up to the challenge yet!'

As consumers' expectations of coffee constantly rise, it's only a matter of time before they join Union in their demand for quality, even at supermarket level. But in the meantime? Union work with 40 different farmers over 13 countries, and roasts across the spectrum – so there's bound to be a Union coffee for everyone.

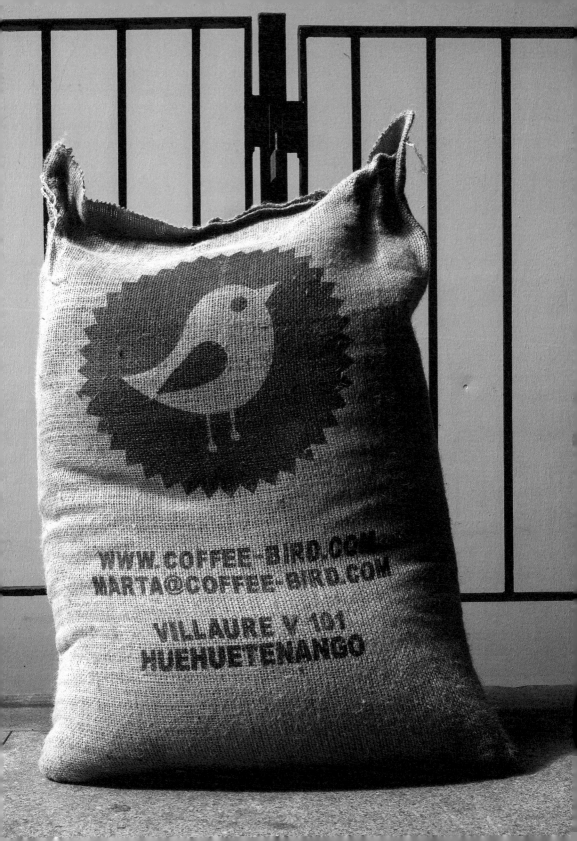

COFFEE BIRD

Descendants of a Central American coffee farming family, aiming to change the way green coffee is traded and bringing more Guatemalan single origin coffees to market.

'My great-great-great grandfather, Manuel Matheu Ariza, started growing coffee in Antigua, Guatemala to overcome the local depression in the 1860s.'

Marta Dalton, co-founder, pictured

In the fanfare that surrounds the biggest and best new coffee roasters, baristas and cafés, the just-as-important people who strive for perfection throughout the rest of the supply chain sometimes remain in the shadows. Marta Dalton, who co-founded Coffee Bird along with her mother, Colomba Dalton, is a green bean exporter and importer trusted by the best in the industry. She's a perfect example of the shortening of the supply chain that is evolving alongside the growing interest in speciality coffee: part of a six-generation Central American coffee farming family, she is now based in London building relationships, whilst her mother is in Guatemala working with farmers.

'My great-great-great grandfather, Manuel Matheu Ariza, started growing coffee in Antigua, Guatemala to overcome the local depression in the 1860s. Everyone had been growing cochineal, an insect that lives on cactus. It's harvested for its carmine – a fabric dye – then German industrialisation happened and demand disappeared. Manuel had heard that the Jesuits were growing coffee in the northern rainforest part of Guatemala.

So he obtained some seeds, borrowed some land in Antigua [which is now Marta's family farm, Finca Filadelfia], planted coffee and came to London with his first harvest. It cost him a pound – he sold it for four. He returned to Guatemala, and by his second year he was commissioned by the President to show all the smallholders how to grow coffee.'

Marta's parents met on neighbouring coffee farms, so she describes herself as a coffee love child. After a career in finance, Marta decided it was time to get into the business. In February 2011, she decided to head back to her family farm. She learned how to cup and trained as a barista, and thus, Coffee Bird was born.

'I started Coffee Bird to change the way coffee is traded,' Marta says. 'I realised our coffee farm is seven minutes outside a popular town – a World Heritage site – and it's won the Cup of Excellence two years in a row. Yet we were still struggling to sell the coffee, using multiple intermediaries. I thought if my family, who are well-connected business people, are struggling, then how are the little guys in the town over doing – they are totally screwed. And it's true, they were.'

Website
coffee-bird.com

Follow
@thecoffeebird

Marta's mother and sister recently joined the business, making Coffee Bird an all-female powerhouse. As well as selling the coffee from their farm, they also work with coffee producers across Guatemala.

Marta's mother and sister recently joined the business, making Coffee Bird an all-female powerhouse. As well as selling the coffee from their farm, they also work with coffee producers across Guatemala. 'The first time we visited one farm it was my mum, me and the client. The wife of one of the brothers asked where the buyer was – she pointed to the client, and said, "Is that him? He looks so young!" And my mum said, "No, I'm the buyer!" And she was so surprised! "What? You're the buyer? How does your husband let you work?"'

While these days companies run by women are becoming more common, Marta says it's almost non-existent in the coffee trading industry – let alone in Guatemala. 'The social issues are heavy, so we cut through it all with quality,' she explains. And, by her own description, she's ruthless. 'The only way we have been able to build win-win scenarios for everyone is because we have a quality table. At the table I don't care about your social class, if you're rich or poor, educated – we just care about quality and that's what allows us to demand the price.' This means that revenues are going direct to farmers who grow quality beans. Rewarding farmers who simply produce good crops enables them to expand, innovate or undertake education regardless of their social standing. It also helps and motivates farmers to grow more, convert to speciality, and transition out of the debt traps inherent of the traditional model, into a new model where they have full economic freedom. If they can grow high quality, speciality coffee, then they are eligible to trade with London's best roasters: with Marta's help.

This approach was rare when Marta started. Marta says there were a few importers providing traceability, but it was rare to find farming families trading direct. 'I believe that we can build transactions where we all win,' Marta says. 'Coffee Bird is a six-generation coffee family, building the next generation.'

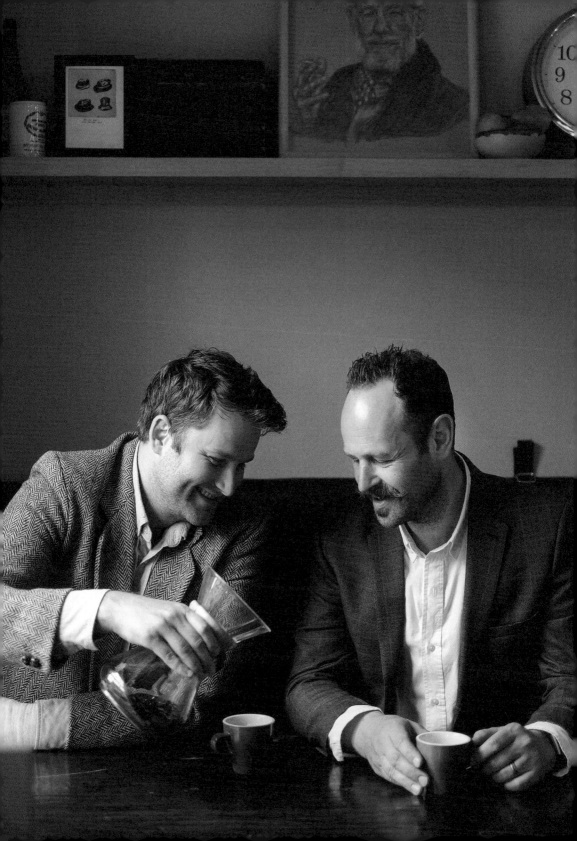

THE GENTLEMEN BARISTAS

'Well-mannered' café cultivating a traditional, welcoming and friendly coffeehouse vibe in a Bermondsey building filled with coffee history.

'Our building was a seventeenth-century coffeehouse, so we wanted to recreate everything they stood for back then. Coffeehouses were where people went to do things; to debate, to research, to discuss.'

Ed Parkes, pictured previously (left) with Henry Ayers, co-founders

'Well-mannered coffee' is the tagline used by Henry and Ed, the two dapper men behind The Gentlemen Baristas. Disillusioned by the welcome they often received at speciality coffee establishments, they aimed to build a refuge from what they've dubbed the 'baristocracy'.

'It is more than just the quality of the coffee – that should be a given,' says Ed. 'Our building was a seventeenth-century coffeehouse, so we wanted to recreate everything a coffeehouse stood for back then. Coffeehouses were where people went to do things; to debate, to research, to discuss. The Gentleman Baristas – the name is tongue in cheek – is about being well-mannered and engaging.'

Over the past few centuries, this building on Union Street in Bermondsey was also the site of a coffee roastery; a green coffee bean merchants – with the proximity of the Thames making it a perfect site for trading in and storing coffee shipped to London from across the globe – and, later on in the early-to-mid twentieth century, the original headquarters of the Coffee Trade Federation. When Ed and Henry took on the building, they found a large stack of cloth-bound tomes containing the original minutes from the federation's meetings. If you ask nicely, you might be able to browse while drinking your flat white. 'It's excellent reading,' Ed laughs, adopting an aristocratic accent: '"Mr Jenkins, from Papua New Guinea, should pay the same rates as so-and-so." And then on the next page, they'll discuss the annual cricket match!'

While they say good coffee should be a given, Henry and Ed still spend time making sure theirs is indeed so. They work with a contract roaster to roast their own range, having decided on their beans and recipes through a long process of cupping and testing.

Sticking to the theme, all of their coffees are named after Victorian-era hats, which might sound whimsical, but just down the road lays the site of a nineteenth-century hatter, where the bowler hat itself was invented. 'We have a bit of an obsession with hats,' Henry admits, gesticulating to the vintage top hats and bowlers stacked behind the counter.

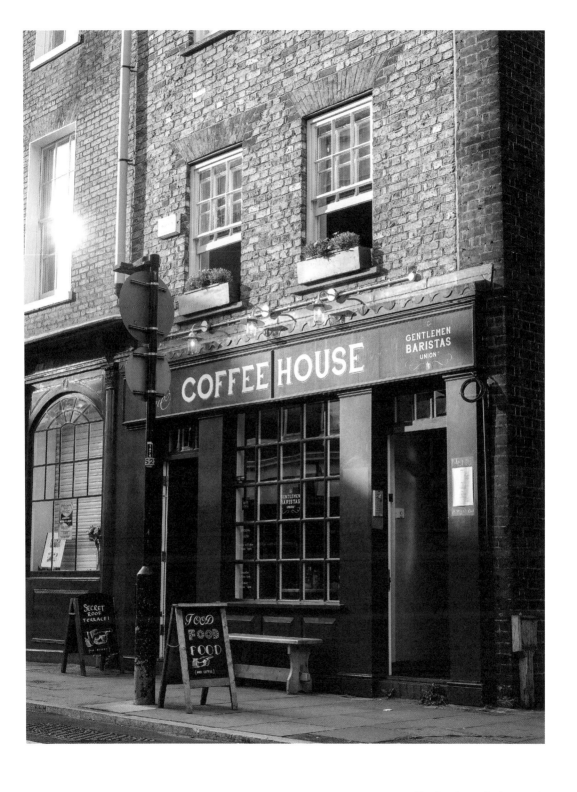

was vacant.

...on added that he wished to record the
...iation of the Society for the services
...d by Mr. Harvey who had occupied this
...since June, 1945. Mr. Harvey had
...sponsible for much of the admini-
...e work of the Society particularly
...its formation.

...Parham having served for the long-
...tinuous period as an ordinary member,
...etire from the Board of Management
...not eligible for re-election for a
...of 1 year.

...Ardouin (Allied Suppliers Ltd.)
...n elected in his place on the Board
...gement by postal ballot.

...e of thanks to the retiring member,
...e Board of Management, and in
...efficient management of the Society's
...y all members present.

...e re-elected as Hon. Auditors for
...of appreciation for their past

...nough
...oper

...a vote of thanks to the Chairman

F. Ardouin

CHAIRMAN
31st MARCH 1960

Original minutes from the Coffee Trade Federation meetings, held on-site throughout the 1900s

Addresses
63 Union Street
London SE1 1SG

The Building Centre
Store Street
London WC1E 7BT

Website
thegentlemenbaristas.com

Follow
@thegentlemenbaristas

All of their coffees are named after Victorian-era hats, which might sound whimsical, but just down the road lays the site of a nineteenth-century hatter, where the bowler hat itself was invented.

Their passion for history is what makes the concept really work. Other intriguing historical details can be sought out by a keen eye – such as vintage coffee grinders repurposed into planters for edible gardens, that sit next to a large barbecue on their roof terrace: a weekend space where they grow and grill food for their customers.

The Gentlemen Baristas has a welcoming, homely vibe, and that's just how they want it. Serving good food and coffee within a jovial atmosphere spurs on the social interaction that took place in coffeehouses of old. 'What we really like is that people are sitting at tables and conversing, which was kind of alien to London,' Henry says.

But while they've captured some aspects of the traditional coffeehouse, luckily a few were left for the history books. For one, their coffee certainly does not taste like the 'base, black, thick, nasty, bitter, stinking, nauseous puddle-water' as it was described in the late 1600s – instead, they offer delicious single origin beans and crafted blends, brewed espresso or filter as you please.

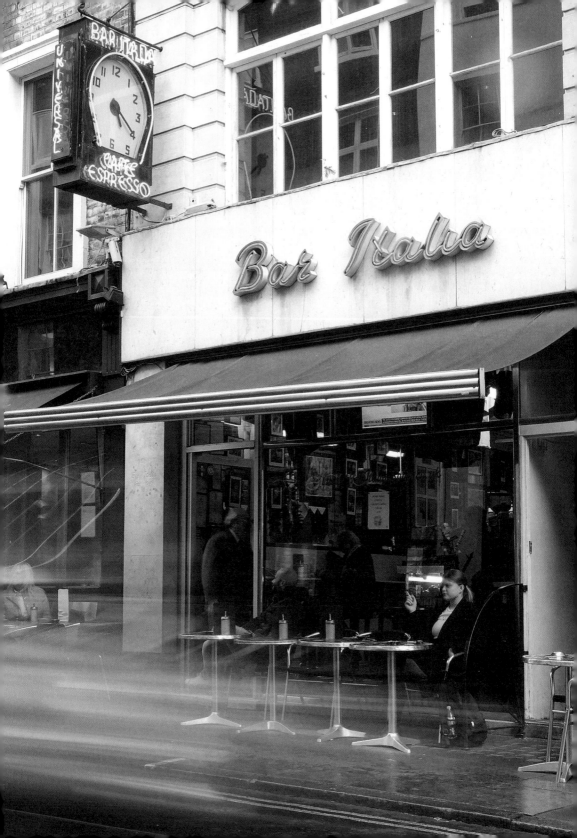

Italian espresso bar
Soho

BAR ITALIA

Cult 22-hour-a-day Italian espresso bar in the heart
of Soho, serving hand-pulled espresso shots
and captivating the imagination of writers, singers
and poets - unchanged since the 1950s.

'The café has taken 68 years to wear in – the floor
has had millions of people walk on it, the fascia
is original, the red and white Formica is original –
and people like it all the way it is.'

Antony Polledri, manager, pictured p. 130

It's just a little place, where good friends come
to meet – this old café is better than the rest.

It's in the heart of Soho, man you gotta go-go –
the coffee that they serve there it's the best.

You can get a nice panino, say ciao to Signor
Nino, catch up on news with old Luigi P.

Bella, Bella, that's amore, this café can tell
a story – Bar Italia is the place for me.

- Lyrics by Ray Gelato

Dressed in a well-pressed suit and armed with a smile from ear to ear, Signor Nino himself walks through the door of Soho's much-loved espresso bar. The two bowtie-adorned Italian bartenders – who have worked at Bar Italia for a combined 40 years – ring the large brass bell hanging above the counter to announce his arrival. The crowd erupts in a chorus of cheerful Italian. Eighty-three-year-old Nino enjoys this raucous welcome twice weekly, visiting for lunch on the same days ever since he retired from the business at age 65.

'Did you see who was sitting out front? That's Ray Gelato!' Nino says, proudly. Ray, the godfather of London's swing revival, and the musician who penned the bar's namesake song, sits out front with a newspaper and espresso as if to prove his point – that Bar Italia is indeed the only place for him.

'Bar Italia was opened in the winter of 1949 by my grandparents Lou and Catarina,' says Antony, Nino's son, and the manager for the past 35 years. 'I'll tell you what happened,' Nino adds, shaking his finger emphatically, 'my family started in the old Covent Garden, when it was a fruit and vegetable market. In 1937, we took on a café there. In those days it was tea, tea, tea, tea and tea. Steak and chips, eggs and bacon. We served very little coffee. What we did serve was an extract that we added to water. The porters were always in a hurry – they would pour their tea or coffee into a saucer to make it cool faster, and off they'd go again.'

In 1949, they took on the lease at Frith Street, and the Bar Italia known and loved today has been open ever since. Their now-quaint hand-lever Gaggia espresso machine was fitted soon after the café opened, and, while they've been through a few of them (the machine is on and making coffee 22 hours a day), they've always stuck with the same model. Tourists and locals come to witness the spectacle of hand-pulled espresso day and night – although Nino admits British consumers didn't take to the drink immediately. 'A lot of people didn't understand what espresso was, and it wasn't to their liking, to be honest.'

These days, the streets of Soho are packed with coffee shops, but Bar Italia has always provided more than just a good cup of espresso. 'We've had a handful of marriages, customers who have met here. Some of our customers had children, and the first place they bring their child is to Bar Italia,' Antony says. 'One customer came in and their child was named Nino, after me!' Nino adds, laughing.

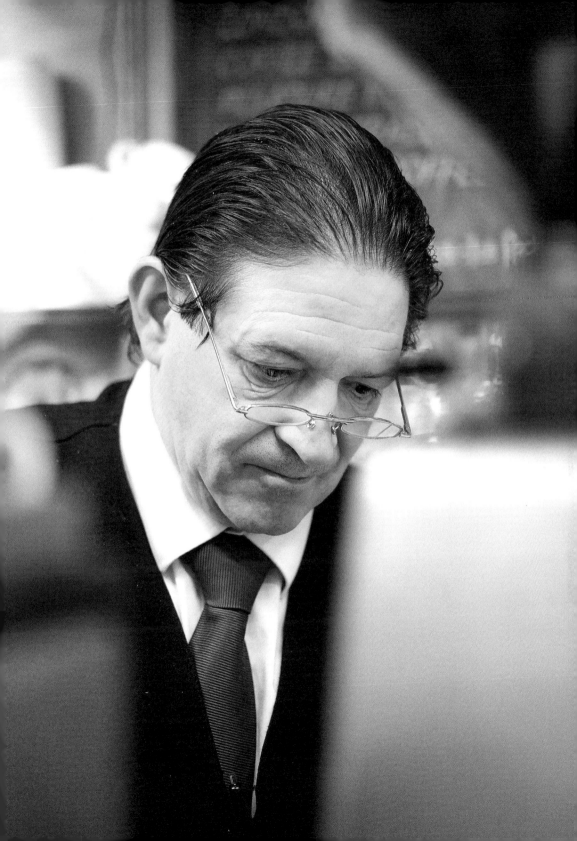

Address
21 Frith Street
London W1D 4RN

Website
baritaliasoho.co.uk

Follow
@TheBaristas

'My family started in the old Covent Garden, when it was a fruit and vegetable market. In 1937, we took on a café there. In those days it was tea, tea, tea and tea. Steak and chips, eggs and bacon. We served very little coffee.'

Nino Polledri, owner, pictured p. 129

So what's the secret to their longevity? Antony says, 'We do not deviate, and we do not compete. We've never followed these big fads – buckets of coffee and syrups. It scares me that every time I look, the big guys are coming up with these different fandangled things. You think, "should I be doing this?" But we haven't deviated from the European route, and we just try to make the best coffee possible. It's exactly the same as what you would get if you went into a little café in Italy.' The charm of the place, paired with the guarantee of a good, consistent, Italian espresso brings a certain appeal to customers young and old alike. 'I'd like to think we are well-regarded,' Nino says. 'Our coffee is authentic, and everything we sell is genuine.'

While true authenticity is hard to come by these days, Bar Italia is the epitome of the term. They haven't changed the décor since their first renovation in 1950. 'People relate to the original style Italian coffee bar,' Nino says. Antony agrees, with no changes to the café on the cards. 'The café has taken 68 years to wear in – the floor has had millions of people walk on it, the fascia is original, the red and white Formica is original – and people like it all the way it is.' That goes for the coffee too: Angelucci's Coffee, their supplier, could be found a mere two doors down from the café until Mr Angelucci passed away a few years ago. They have been supplying Bar Italia with their own special blend since the 1960s, and luckily his sons have taken over the business – although now supplying from a little further afield, in Finchley.

Throughout the decades, Bar Italia has cemented itself as a Soho institution. It's always been popular with celebrities and Antony speaks of meeting 'all the superstars that I wanted to meet when I was in school. Kylie Minogue, David Bowie, Adam Ant.' Nino can't even begin his long list – 'mention a few people to me and they've been here, I'm sure'. A fan of the café, singer Sade asked Nino to feature in her music video for her hit 'Smooth Operator'.

Pulp also immortalised the café in song, celebrating Bar Italia for being the one place to go after a night out in Soho. 'My father saw a transition in Soho in the 1980s – his philosophy was that we wouldn't close the door until the last customer leaves.' Antony says that party-goers have been finishing their nights there since then, and are met with welcome – they are one of his favourite parts of the job. 'One of the best times in Soho is between five and seven in the morning. That's when you have the mix and match between the night before and the early morning, with people going to work. That's what makes my job interesting – seeing the transition, seeing the costumes, the music. There's simply nowhere like Soho.'

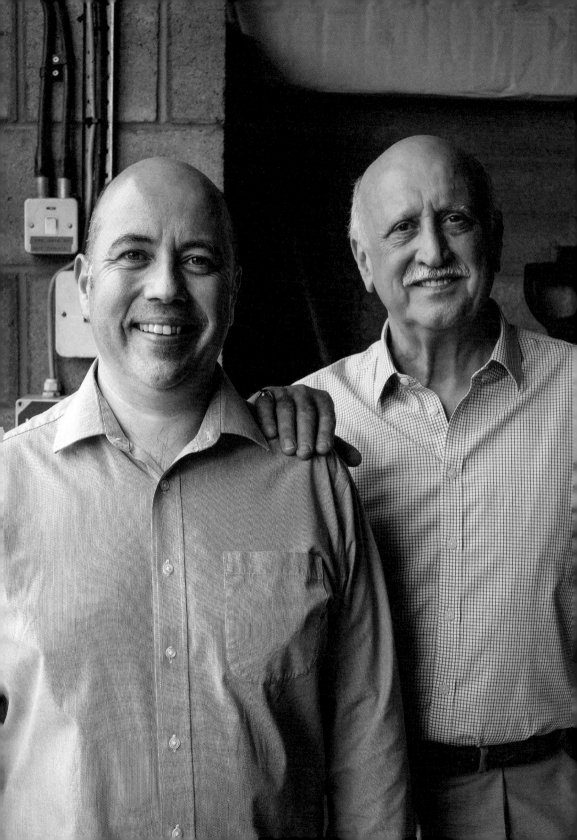

Traditional coffee roastery
Woolwich

DRURY TEA & COFFEE

Large, traditional, family-run Italian tea and coffee company supplying shops, restaurants and homes since 1936; an established and quintessential British household name.

'**When you think about it, these new wave artisan roasters in London are doing exactly what we were doing in the fifties.'**

Marco Olmi, pictured previously (left) with Dino Olmi, directors

'We were there at the beginning,' says Marco Olmi, Commercial Director of multi-generation family business, Drury Tea & Coffee. While many of today's coffee businesses in London have only been around for the second or third wave movements, Drury really helped kick off the city's obsession with espresso-based drinks back in the 1950s.

'We started roasting the first espresso in London,' Dino Olmi, Marco's uncle and the company's Managing Director, says. 'There were beans roasted for espresso in Italy of course, but there weren't many being imported – if any – at that time. The espresso machines were just starting to come in too.'

The Olmi brothers started the business with tea alone, blending it by hand with wooden shovels at their first site in Windmill Street, Soho. 'The story my father always told was that when they opened in 1936, they originally called it Olmi Brothers' Tea and so shortened it to O.B.T,' Dino says. 'He thought it looked very nice on the packets. But he got fed up with the porters coming in from Covent Garden fruit and veg market and saying, "Tony, can you give me another packet of Old Buggers Tea?"'

They moved their business to Drury Lane in 1939 and started selling coffee – originally buying it in already roasted before they bought their first roaster in the late 1940s. 'The day the war started our coffee supplier called us and said, "I'm sorry, now you are the enemy,

I'm afraid we can no longer supply you",' Dino says. 'My father called another company and explained the situation and they said they'd be delighted. We still buy about 95 per cent of our green coffees from them today.'

In 1946, the Olmi brothers changed their name to Drury Tea & Coffee. While they've upsized first to Waterloo, then Bermondsey, now Woolwich, the name is a reminder of their deep roots in the heart of London.

Theirs is truly a story of independent success: a business that managed not only to survive long-term – throughout wars, recessions and the ever-changing tastes of the masses – but to grow sustainably; keeping its values and philosophies, and remaining family-run and close-knit through the decades. Now over 80 years old, the company is still run by Olmi boys, descendants of the three Italian brothers who started the business.

With around 50 types of coffee offered at any time, a wide range of tea and a newly released speciality coffee label, Drury has perfected the art of catering for every customer. Marco says they roast a lot lighter now in general, as the industry focus is often on the provenance of the beans themselves, but they still have a lot of customers who prefer their more traditional, darker roasts – Dino admits he is one. Drury focuses on providing whatever their customers want, meaning their products change with the times.

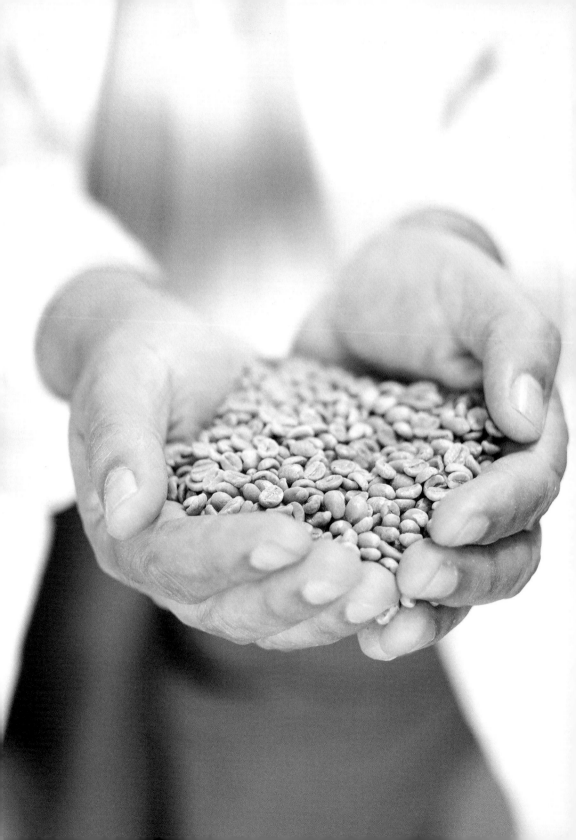

Theirs is truly a story of independent success: a business that managed not only to survive long-term – throughout wars, recessions and the ever-changing tastes of the masses – but to grow sustainably; keeping its values and philosophies, and remaining family-run.

'It's difficult to say no,' Dino says, 'when a prospective good client comes in and they say, "I like the coffee, can you roast it slightly lighter or darker?" When you know you can do it very easily, you don't want to turn business down.' It's this acceptance of and provision for diverse tastes that keeps them relevant and on the breakfast tables of British consumers across all age brackets.

'When you think about it, these new wave artisan roasters in London are doing exactly what we were doing in the fifties,' Marco smiles. Though Drury have certainly scaled up since then – their current roaster has the capacity to produce around 2,000 tonnes per year – but the focus on their beans, sourcing, recipe tweaking and flavour profiles is a similar process followed by the new wave companies.

'The past few years we have been looking at speciality coffee,' Marco says. Launched at the 2017 London Coffee Festival, Drury's speciality beans – sold under the label Windmill Street Coffee in a nod to the company's original location – stood strong among competitors. 'Our head barista trainer is very involved in speciality coffee. She has helped drive Windmill Street Coffee and gave us the kick up the backside we needed. While it's never going to overtake our main coffee business, it is important. What it is doing is feeding back knowledge and ideas to Drury, and while we will keep our core coffees and our approach, there will be some positive influences on the Drury side too over the next few years.'

Address
Retail Shop
3 New Row
London WC2N 4LH

Website
drurycoffee.com

With around 50 types of coffee offered at any time, a wide range of tea and a newly released speciality coffee label, Drury has perfected the art of catering for every customer.

Detail of a coffee roaster (left), with freshly roasted beans being sucked out of the roaster (above) and then diverted to various packing stations

Where Drury differ from the new wave roasters (apart from their diversity in roast profiles), is in the specialised packing machines, coffee sack lifts, silos, measuring technology and equipment they use to increase efficiencies. With machinery assisting with the laborious tasks, the teams can focus on roasting coffee and projects such as developing sustainable packaging options – like their bulk delivery option for large-scale coffee users.

'Rather than getting them in kilogram packs, big users have their coffee delivered in 12kg hessian sacks,' Marco says. 'It's cheaper, we cut down the packaging, we cut down on the energy used to pack it, it's environmentally friendly, and hessian sacks are recyclable. We use a polythene liner to improve the shelf life, but that's one bag for 12kg of coffee, compared to a cardboard box and 12 foil bags.'

Drury have over 1,000 trade customers across the UK, so odds are you've tried their coffee in one of the many restaurants, bars and cafés that serve their beans. Rumour has it that their customers have around 25 Michelin stars between them, but their coffee can also be picked up from their Covent Garden retail store if you'd prefer to try their coffee without the restaurant bill. Known for being a 'traditional British tea and coffee merchant', they are a hit with the tourists, and are a perfect example of how coffee has been an integral part of British culture for some time. 'We have a few customers where their dads have bought from my dad, and their grandads have bought from my grandad!' smiles Marco.

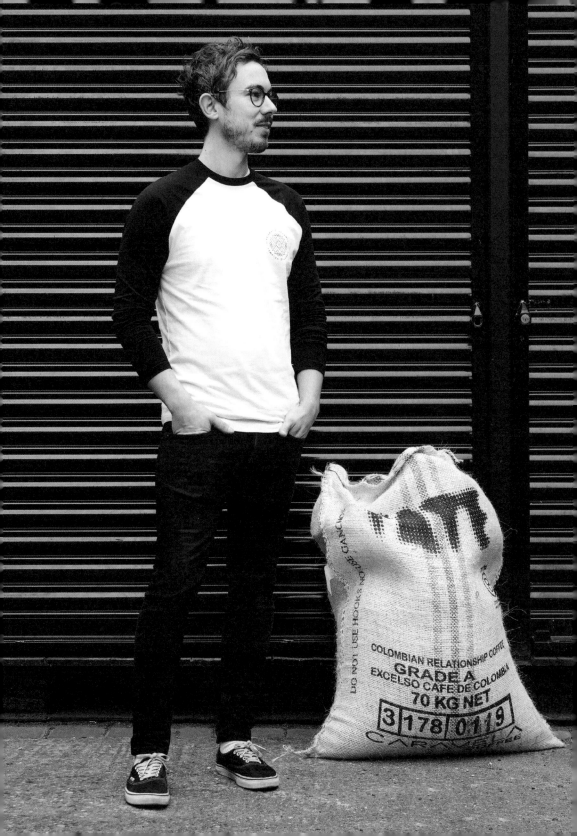

COFFEE BY TATE

Art gallery coffee roastery, sourcing, roasting and brewing speciality coffee, with a commitment to quality.

'We'd probably sell a million cups of coffee per year.
We roast 22 tonnes of coffee for use just in our shops.'

Thomas Haigh, Head of Coffee, pictured previously

Tucked away in the grounds of Tate Britain is a little Second World War Nissen hut, home to the one-man show that is Coffee by Tate. Thomas Haigh (ex-Head of Coffee at Climpson & Sons) is far from alone, though: he's part of the larger Tate Catering family, a collective of talented specialists ensuring that their food and drink offerings are very unlike your usual museum cafeteria-style fare. Direct sourcing, in-house wine aging, coffee roasting and dedicated chocolatiers are all the result of the decision to bring all stages of their food production 'in-house'.

Thomas says, 'It's a way of getting better quality products, and really focusing on the story behind everything. Tate embraces creativity. The ethos behind Tate is to strive continually for more accessibility as an institution – but how do we get there? We can be as creative and innovative as possible.'

One of the key benefits of the Tate galleries having their own coffee roasters is that Thomas can work closely with the barista team to ensure quality and standards stay high across all of their sites. He often runs workshops and classes for staff to attend if they want to learn more, bringing specialist knowledge within reach of the army of staff who prepare his coffee beans every day. This not only means they make better coffee; they can also talk to customers about coffee in an educated manner – something now expected by consumers within dedicated coffee shops, but a pleasant surprise at an art gallery.

Working within a large creative institution has allowed Thomas the opportunity to think about coffee in a different way, too. 'I can be more involved with the producers. Rather than just looking at quality, I can look at things like how gender plays out in different cultural circumstances at origin.' Their new gender equality project takes a unique perspective on women in the coffee industry, aiming, where possible, to ensure that coffees are sourced 50-50 between male and female producers.

ROASTED BY TATE WITHIN
THE GROUNDS OF TATE BRITAIN

GALLERY
ESPRESSO

75% FINCA EL CASHAL, LAMATEPEC, EL SALVADOR
25% FINCA SAN ERNESTO, COMASAGUA, EL SALVADOR

A sweet and well-structured blend of Bourbon and Pacas
Honey processed coffee, this espresso is fruity and clean with
notes of blackberry, treacle and cola

TATE MADE

Address
Tate Britain
Millbank
London SW1P 4RG

Website
tate.org.uk

Follow
@tateeats

Being what he calls an 'arts roaster', Thomas also aims to bring the arts into the farming communities he works with.

Coffee by Tate is able to develop their relationships with producers, assisting them in gaining access to the market, and invests in farms. 'We want to see where these relationships go, and how we can better their coffee quality, but also further the lives of the people we work with.'

As part of a larger not-for-profit, Tate Roastery is becoming a bit of a coffee community hub as well. Operating slot sessions, they rent out their roastery to budding roasters before they make the jump and invest in their own equipment. Some of London's better-known coffee roasters and cafés started out here, slowly growing demand for their beans until they could build a roastery of their own. While Tate beans are sold in limited speciality stores throughout the UK, their main focus is on providing for their 18 in-house shops. 'We'd probably sell a million cups of coffee per year. We roast 22 tonnes of coffee for use just in our shops – your standard, fairly busy coffee shop would go through about two tonnes a year.'

Being what he calls an 'arts roaster', Thomas also aims to bring the arts into the farming communities he works with. 'Richard Mittens – he's one of our volunteers at Tate – is a budding artist. He has just started painting portraits of the roastery to give back to our producers, to tie the art back into the story. He painted me in front of the roastery too – I've got really skinny legs, but I think it's a pretty good likeness!'

Boxes of test roasts (above), inside the small brick Nissen hut, home to Coffee by Tate (left)

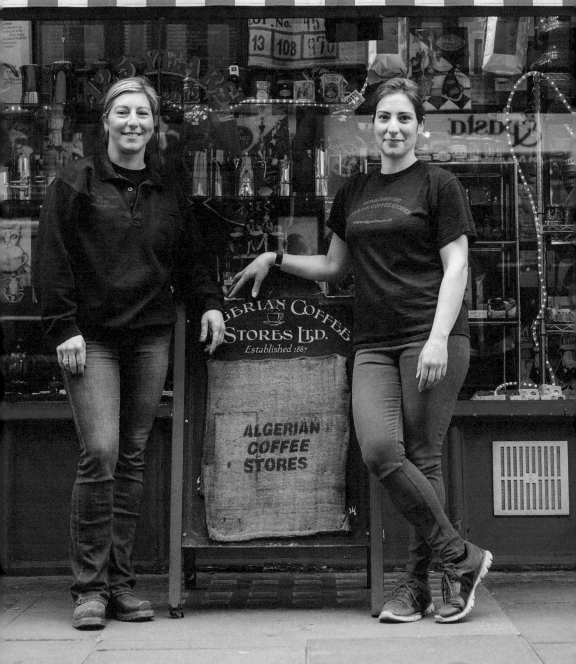

ALGERIAN
COFFEE STORES

Sold-by-weight historic coffee store in Soho,
offering over 80 global coffees to buy and take home,
or their famous £1 takeaway-only dark espressos.

'Most of our coffee will be roasted and out the door within a few hours.'

Marisa Crocetta, pictured previously (right) with sister Daniela Crocetta, co-owners

The old wooden counter inside 52 Old Compton Street, Soho, is scuffed and marked by decades of scissors, coffee scoops and briefcases. Amid a flurry of brown butcher's paper torn from the roll and deftly manoeuvred scoops of fresh roasted coffee, eight workers swiftly pack orders and operate a well-used espresso machine, filling hundreds of tiny paper cups with dark, strong espresso to fuel the busy people of London. The whir of the grinder, the scrape of old wooden drawers filled with fragrant coffee and the array of accents of those who wait patiently in line are punctuated by the cymbal-like patter of coffee beans as they are poured onto the old metal scales.

'This is the best place for coffee in London,' says one of the regulars, firmly. It's certainly the best value – their £1 espressos have customers lining up out the door day after day. The dark-roasted Formula Rossa is a house-made blend that makes up a large percentage of the 1.5 tonnes of coffee they sell per week, and has been served in their takeaway espressos for decades.

Some of the customers have been coming here for over twenty years. 'The regulars don't like when we change things,' co-owner and manager Daniela Crocetta admits. 'Donkey's years ago, my dad painted the shop green. There was such an uproar we had to paint it red again a few days later.' Their long-lasting relationships extend beyond their customers – they've worked with the same roaster for over 30 years, and their signwriter has been hand-painting changes in coffee varieties and prices onto the wooden panels for decades.

Algerian Coffee Stores was opened in 1887 by a mysterious Mr Hassan, about whom little is known except that he was of Algerian origin. The grandfather of the current owners bought the shop in 1946, and it's been run by the same family since then. Daniela and Marisa Crocetta, the two sisters who manage the store today, grew up there.

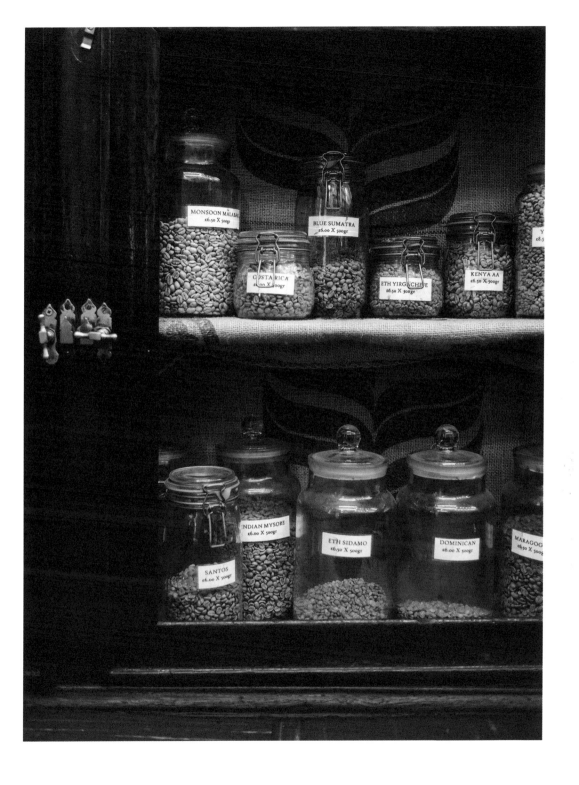

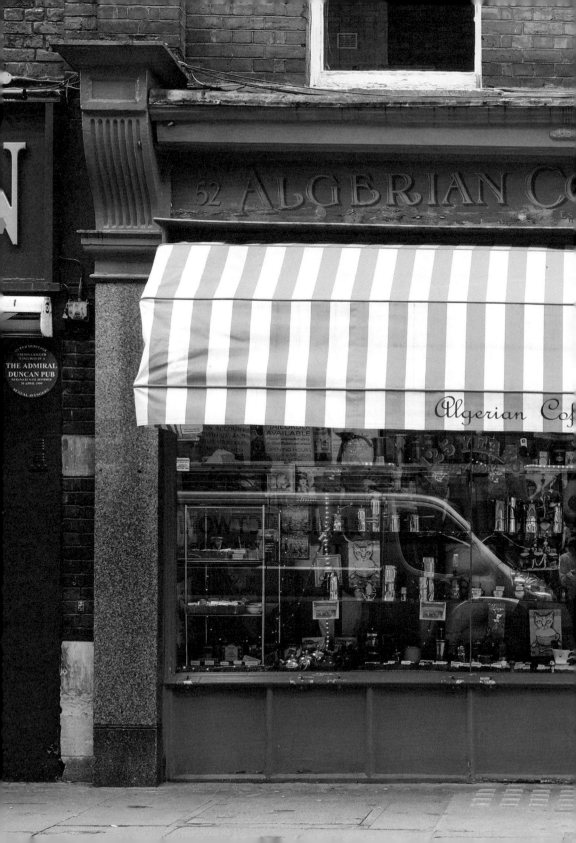

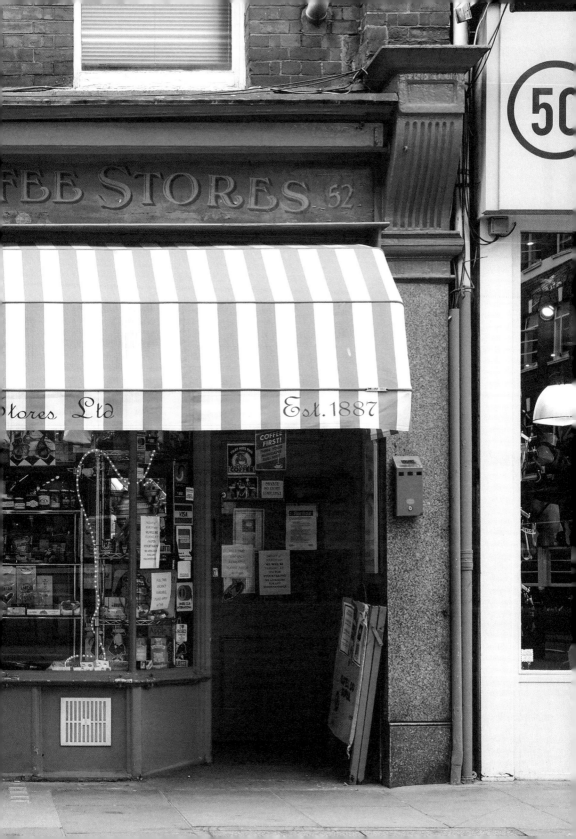

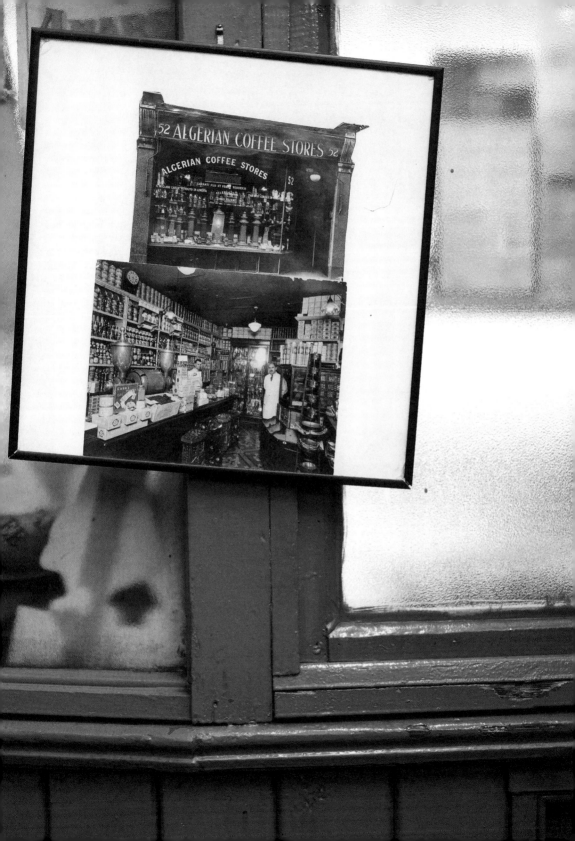

Address
52 Old Compton Street
London W1D 4PB

Website
algcoffee.co.uk

Eighty different types of coffee are on offer, including Arabic blends with spices, traditional Italian coffee blended with fig, and green, unroasted beans too.

'We've had chocolate figs here since I was a kid – they are a seasonal Calabrian product. People go mad for them,' Marisa says. 'I used to help with the books and the cleaning and steal the chocolate figs.' It's this family history that adds to the charm. The fit-out and style of service haven't changed in decades – some of it, a century – though it certainly isn't twee. Some places that preserve their history feel as if they do so as a gimmick; Algerian Coffee Stores operate their decades-old model because it's a perfect, well-oiled operation that their customers trust.

Eighty different types of coffee are on offer, including Arabic blends with spices, traditional Italian coffee blended with fig, and green, unroasted beans too. 'Some of the coffee you see around in shops in pre-packed bags is months old. We don't want to pack it all up because you don't know how long it's going to be sitting on a shelf for. Most of our coffee will be roasted and out the door within a few hours.'

To make sure their customers don't need to hold beans for too long, they sell any weight a customer desires, starting from a minimum of 125g. 'A lot of places don't use fresh beans or good quality coffee, and I can taste the difference,' Marisa says and crinkles her nose. 'I look forward to coming home to have coffee.'

Small batch roastery and café
Homerton

DARK ARTS COFFEE

Coffee roastery breaking all the rules in a
small railway arch in Hackney, and serving
vegan brunches right out of their workshop.

'We roast beans until they taste good as a brown drink.'

Bradley Morrison, co-founder, pictured previously

Take a stroll in the underdeveloped East London borderlands of Homerton and Clapton, and you'll find the landscape littered with uniformly dilapidated railway arches. If luck is with you and the wind is strong enough, you might catch whispers of a faintly squealing guitar solo. Find a twirling cloud of coffee chaff and then follow the sound of revving motorcycles and perhaps you'll stumble upon the coolest coffee roastery in town: Dark Arts Coffee. Their mission statement is simple: 'we roast beans until they taste good as a brown drink'.

While unmarked outside except for the steam-train-like ventilation duct pumping out a snowstorm of coffee chaff, inside the railway arch is packed with coffee roasting equipment and paraphernalia of various descriptions: motorbike helmets, old movie posters, framed *TIME* magazine covers from the 1940s. 'We used to have a goat's head up in here. Our friend took it to Leeds, so we've been trying to replace it. It's really hard to find a good goat's

head,' says Bradley Morrison, the long-haired, motorbike-loving Kiwi founder.

'We didn't really want to have a café in our space, but people just kept coming and asking for a coffee. It was cool, but we realised we were kind of giving away a lot of free coffee,' Bradley says. 'We just wanted it to be a hub for our friends.'

But word got out, and now Bradley's girlfriend Talia cooks brunches in the corner of the roastery to feed old friends and strangers alike. They decided to flip the traditional menu model on it's head: where you usually find just one vegetarian option, the aim was to create a café where everyone could choose from a large range of options, no matter their dietary preferences. They've gained fans for their house-made, soy-free vegan chorizo, their vegan pastries and their ever-changing brunch dishes such as Brazilian fish cakes with wild garlic sauce, or black Beluga lentil dahl with their own green tomato chutney.

Address
Arch 216, 27 Ponsford Street
London E9 6JU

Website
darkartscoffee.co.uk

Follow
@darkartscoffee

They've gained fans for their house-made, soy-free vegan chorizo, their vegan pastries and their ever-changing brunch dishes such as Brazilian fish cakes with wild garlic sauce, or black Beluga lentil dahl with their own green tomato chutney.

And their coffee stands up with the best of them too. The small team comes from an all-star coffee background, with experience across the London scene. Everyone has their say – they work like a collective here, and roast whatever beans take their fancy.

'We cup everything together and whatever we like, we buy. We don't really stick with anything in particular – it's just what's good. We update our roasting profiles every week, we try and keep it as fresh as possible,' says Gary Regan, Head of Quality.

When designing the business and the brand Bradley decided to subvert the oft-replicated coffee roastery model. 'I didn't come from a lot of experience, so we just made Dark Arts about what we liked instead. I've been riding bikes since I was a kid. I like cool bikes. My friends like cool bikes. Cool bikes are cool. Just put the bike in the photograph somewhere, and someone might think we are cool,' Bradley laughs.

Though they don't need to do much convincing. Their laid-back, friendly attitude and the museum of curiosities feel to their décor makes Dark Arts a place you want to hang out. The army of creative friends who stand behind the business include their packaging guru Nick Dart, who did the artwork for the last Black Sabbath album, and the man behind their logos, Simon Erl, who is a well-known tattooist.

Dark Arts feels like that cool university hangout where you'd always find a few friends – and Bradley that friendly, down-to-earth guy who would always crack open a beer for you as you walked in the door.

ETHIOPIAN COFFEE CEREMONY

A traditional coffee ceremony from coffee's birthplace, roasted and served by hand in one of London's friendly and welcoming Ethiopian/Eritrean restaurants.

'As children we would run around and lick the sugar out from the bottom of the cups. We were used to caffeine from a young age.'

Benyam Abbay, co-owner of Mosob

The dimly lit room at the back of Mosob Restaurant in Westbourne Grove is decorated with fur rugs, woven baskets and pictures of injera: a teff flour fermented pancake common in Ethiopian and Eritrean cuisine. Smoke, like a phantom dancing cobra, rises from a little brightly coloured wicker basket filled with frankincense and hot charcoal.

'Some people refuse to drink coffee unless frankincense has been burned. It gets rid of negative energy,' says Benyam, one of the owners of this family restaurant that feels more like a home than a business. His children run through the room and jump on his lap to watch as the ceremony starts.

A more intense smoke begins to fill the room and mingle with the incense, accompanied by the snap and crackle of coffee beans as they are shaken in their metal roasting pan. A woman wearing traditional dress hosts the ceremony, and she is the master of the show. She undertakes her work with ease and unwavering concentration – it's a well-practised routine, executed with the precision of a Japanese tea ceremony. Coffee is serious business in Ethiopia. It is said the humble bean was discovered there, so coffee traditions run deep within the culture. 'Often when we walk around London, we will smell coffee and frankincense and say, "Ah – one of us is around",' Benyam laughs.

The beans start to pop over the small fire, turning a dark brown. The beans are roasted past second crack and start to glisten as they release their oils. The Ethiopian style is traditionally a very dark roast; however, brewing with sugar and various aromatic additions richly pairs with the roasty flavour notes for a truly unique coffee experience.

The hostess walks the pan around the room, encouraging all her guests to wave the smoke towards them and inhale; tradition demands this, meaning smoky parades through the restaurant are undertaken each time coffee is ordered.

The pure Arabica beans barely emit any scent until, still hot, they are ground coarsely – it doesn't come fresher than this. They have a sweet intensity, and this preparation method proves how versatile an ingredient coffee is – the experience is a world away from the flat whites of East London or the Italian espressos of Soho, though equally as delicious.

The coffee ceremony is a ritual performed daily in Ethiopia and Eritrea – though there, it's not a ceremony at all. 'It's just coffee to us,' Benjamin laughs. 'It's just how we make it for friends and family.' An offer to join someone for coffee is a show of respect or friendship: a welcome prepared for any guest, at any time of the day.

Address
Mosob
339 Harrow Road
London W9 3RB

Website
mosob.com

Follow
@MosobUK

Coffee is serious business in Ethiopia. It is said the humble bean was discovered there – so coffee traditions run deep within their culture.

The brewing pot, made from clay and called a jebena, is filled with the hot, ground beans and water and brought to a boil over the fire. As the brew bubbles and boils over the top, the hostess deftly tips a little into a small jug, and then pours it back into the pot, returning it to the fire.

'Tradition and culture tells her when the coffee is ready,' Benyam narrates, 'she will judge by the colour and the smell.' The brew gets darker and more syrupy with each pour, and finally the pot is removed from the fire and the grounds are left to settle. In Ethiopia, a filter of balled-up horsehair would then be pushed into the neck, although UK health regulations have required adaptation – they use a cleaned piece of onion sack here. Sometimes guests who have the money to spare request a bundle of saffron to be used instead, adding a floral note to the coffee poured through. In other parts of Ethiopia and Eritrea, different spices may be added before brewing, such as cardamom, cloves, cinnamon or fresh ginger.

The dark, soul-warming brew is poured into tiny cups from a height and handed out to guests. The skill required in pouring from such a height, along with the constant adjustment of the angle of the pot to filter out any grounds, is a technique perfected through much practice. The pot is immediately refilled and returned to the fire. As Benyam hands out the cups, he explains, 'We keep drinking until there is no flavour left in the coffee – the taste changes each time we brew.'

The heady sensory experience intensifies as the second brew starts to boil, and another integral part of the ceremony is introduced, providing a perfect, crunchy counterpart to the rich aromas of coffee and frankincense. Popped corn kernels are offered around in bowls – although, in Ethiopia they would usually serve popped sorghum, which look similar to corn, but are about a quarter of the size. Sorghum is an earthy, nutty grain crop cultivated in Africa for over 4,000 years, though unfortunately it's much harder to come by in Europe.

Benyam explains his theory behind the Ethiopian ability to drink such an extraordinary amount of caffeine. 'As children, we would run around and lick the sugar out from the bottom of the cups. We were used to caffeine from a young age. Now when I visit my sisters, I might drink six to ten cups of coffee.' The coffee is usually poured on top of many spoonfuls of sugar, and the amount of sweetness desired by each drinker is achieved by how much this sugar layer is stirred into the drink. 'Sometimes the cup might be half full of sugar,' Benyam smiles. 'We do like our coffee sweet.'

Antipodean speciality roastery and cafés
Dalston & Shoreditch

ALLPRESS ESPRESSO

New Zealand-founded traditional coffee roastery
and cafés, focusing on balanced espresso blends
in a converted factory in Dalston.

'We don't rush to do the next "thing". It's always been medium roast, nice full body, nothing too lemony or ripe – just good old-fashioned coffee.'

Cam MacFadyen, Head Roaster

This open-plan, contemporary coffee roastery and café in a repurposed 1930s joinery factory in Dalston could easily be mistaken for a very modern addition to the coffee scene, but the light-filled industrial space is home to a coffee company with a 30-year history. While a relatively recent arrival on the UK scene – they opened their first space on Shoreditch's Redchurch Street in 2010 – the Antipodean roots of Allpress go back to 1986.

Founder Michael Allpress was working as a chef in Seattle, where he came upon a burgeoning speciality coffee scene. He returned to Auckland, New Zealand, and made his first foray into coffee with a few coffee carts and a garage roaster. Fourteen years later and Allpress expanded into Australia with the help of Tony Papas (pictured, right), another respected Kiwi chef. Shortly after that, Tony took Allpress all the way to the UK and Japan.

The crowning jewel in their Dalston building is their immense hot air roaster, which was custom built in New Zealand and is at the centre of the Allpress philosophy. The building was designed so that you should be able to see it from wherever you are.

'There are two ways to roast – with a drum roaster, or hot air,' explains Head Roaster Cam MacFadyen. 'Michael Allpress fell in love with hot air roasting about a decade ago; we prefer it for consistency and flavour reasons. It provides a really clean, even roast. Basically, a gas burner heats up air inside a chamber. The air is then pulled out of the burner and into the base of the roaster. There's a perforated grill that disperses the air evenly, and the coffee beans are blown around inside.'

They may have one of the most state-of-the-art, publicly accessible roastery around, but they've certainly done the hard yards to get to this point. 'Our old Shoreditch roastery was three stories high. We had a rickety old elevator that could take four 70kg sacks up at a time. We'd get deliveries of 60 sacks, and we would need to take them up to the top and then manually lift them off. Our coffee used to go up and down about five or six times before it left the site,' Cam says. They moved most operations up to Dalston in 2015, while their Redchurch Street space remains as a coffee bar, catering to their loyal Shoreditch-based fans.

Allpress now produce about four tonnes of roasted coffee per week from their Dalston space alone. It's a perfect craft business success story, but along the way they've had to face the question of how, as a 'craft maker' producing high-quality products, they can maintain both their vision and standards as they go from a small business through the eventual expansion that comes from success.

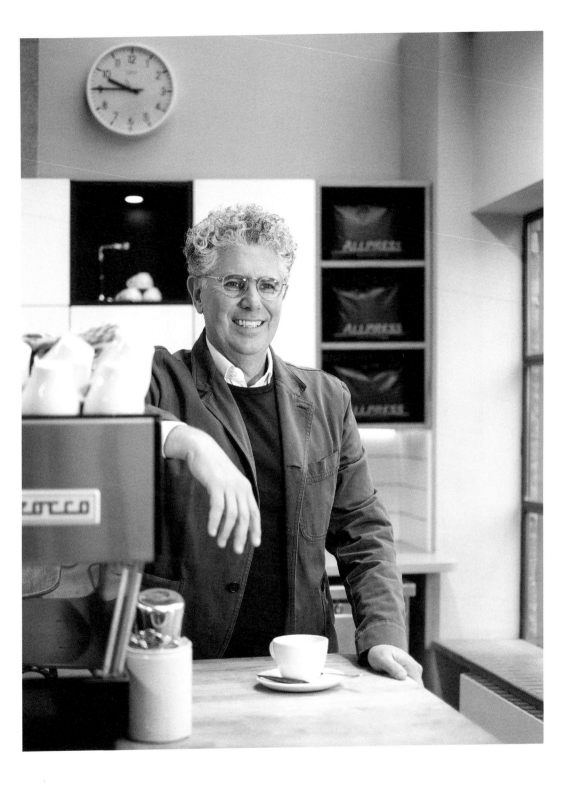

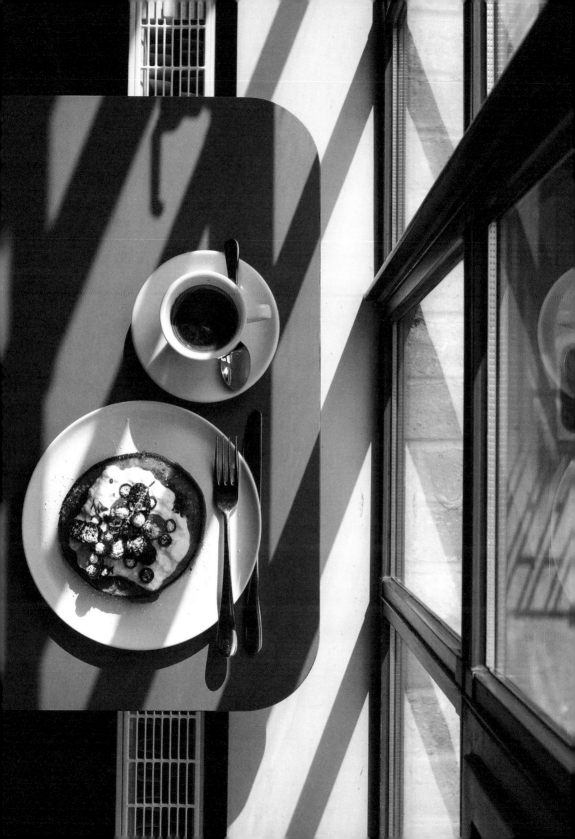

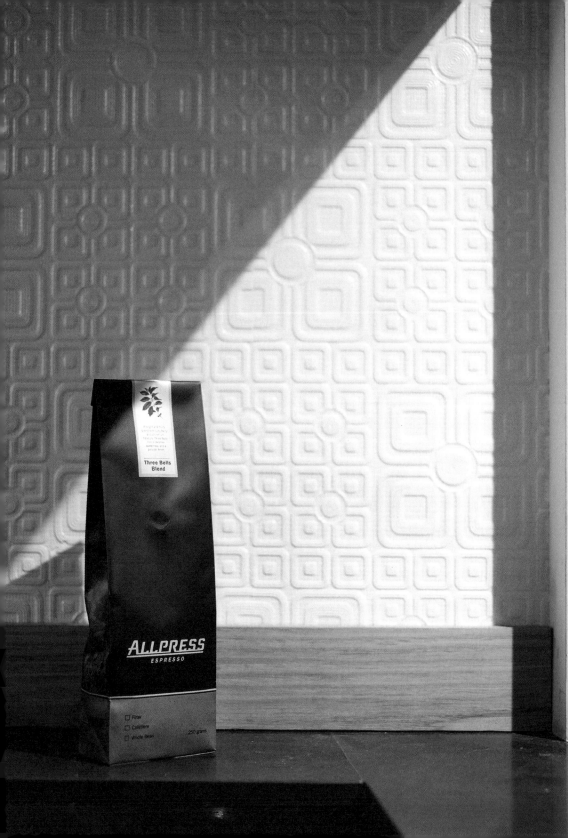

Addresses
Roastery/café
55 Dalston Lane
London E8 2NG

Café
58 Redchurch Street
London E2 7DP

Website
uk.allpressespresso.com

Follow
@allpressespresso

The crowning jewel in their Dalston building is their immense hot air roaster, which was custom built in New Zealand and is at the centre of the Allpress philosophy.

Perhaps it's because many of their management staff have been with them for over 20 years that they can be up-to-date and modern while adhering to their original philosophies. Or perhaps, as Cam says, it's because 'we don't rush to do the next "thing". I've been with the company five and a half years, and the coffee hasn't changed too much in that time. We are always improving the flavour – whether by tweaking the roast method or changing our roasters – but we haven't changed our style. It's always been medium roast, nice full body, nothing too lemony or ripe – just good, old-fashioned coffee.'

While the industry in London swings back and forth with dizzying speed between trends in popular origins, varietals, brewing and roast styles, Allpress maintains their long-standing signature espresso flavour profile by creating a balanced coffee blend. Cam says, 'It's quite common to see single origin espresso these days, but it's something we don't really do. We are shooting for a set flavour profile. The beans in our blend are from Brazil, Guatemala, Colombia and Sumatra. We've been roasting this signature blend for over 20 years.'

'We pre-blend the beans before roasting, and always have. We are very strict on the beans we buy – they all have to be the same size and density so they will roast evenly. The recipe changes very slightly: if we have a fresh batch of Colombian or Guatemalan beans come in, you would expect a lot more acidity, so we tweak it to keep it within our flavour profile.' This consistency in flavour year-round makes Allpress's coffee a popular choice for cafés countrywide. As well as selling coffee, Allpress provides coffee machines and upkeep, and undertakes extensive barista training, running two barista skills courses per day to ensure that their beans are served to customers as intended, whether that's in London or Leeds.

Without dedicating all their time to keeping up with trends, Allpress have been able to focus on improvements across all facets of their business. Anyone who is interested can have a tour of the roastery, or take part in the 'Make Your Own' coffee space, where Allpress staff hand over the reins to the customers to make their own (free) drinks. Whether it be designing custom coffee roasters, or minimising waste (all their coffee grounds are used by local Hackney City Farm), or even decreasing emissions (the solar panels installed in the roof can power the entire building over summer), Allpress's dedication to all-round excellence is clear.

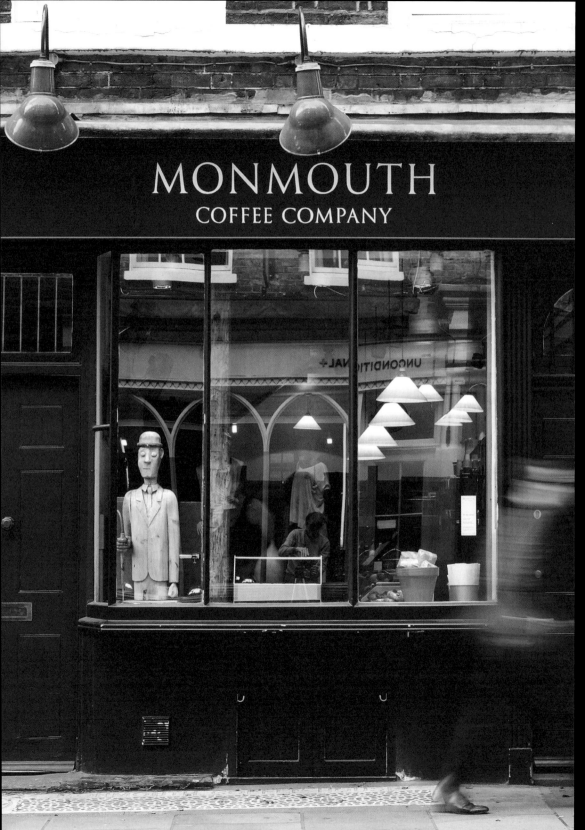

MONMOUTH COFFEE COMPANY

Trailblazing speciality coffee roastery and two busy coffee shops, leading the charge in single origin coffee since 1978.

'It was very hard to find coffees that I thought would be interesting, exciting and had a provenance. I was told there wasn't a demand for it.'

Anita Le Roy, founder

Back in the 1970s, the area around Covent Garden was very different from the tourist district it is today. The fruit and vegetable market moved out in 1974, and the area was home to a diverse range of workshops and light industry, such as bookbinders and ancillary industries for the Royal Opera House, like shoemakers and armourers. And it was here that Anita Le Roy – who has been referred to as the Grand Dame of London coffee – opened her coffee roastery on Monmouth Street in 1978.

At the heart of every great industry or community, you will often find a hard-working, passionate, driven and persistent company, person or team. Trailblazers, as they are often known, and in the London speciality coffee world, you need look no further than Monmouth Coffee.

Anita set up Monmouth Coffee Company with her original business partner, Nicholas Saunders, as a retail outlet and coffee roastery with attached tasting room, where her customers could sample the different types of coffee before they purchased a bag. At the time, they only had £100 for the shopfit. 'We didn't know if it was going to work,' Anita laughs. 'We thought, if it does, we will rebuild our space, but then we didn't have time for another 20 years. It was really successful from day one.'

On the tail end of the city's last coffee boom – the European espresso bars of Soho – Anita set out with a business plan well ahead of its time. Monmouth was really the first to focus on the provenance of the bean itself – bringing coffee into the realm of wine, but without the exclusivity.

'It was very hard to find coffees that I thought would be interesting, exciting and had a provenance. I was told there wasn't a demand for it. The supermarkets didn't have anything but blends for particular times of the day – breakfast blend, after-dinner blend. I thought, coffee comes from farms! But how do we get there? So the next 20 years were a quest to get closer to that.'

Our Drinks

Filter Coffee	3·10
Espresso	2·00
Marchiato	2·00
Piccolo	2·00
Flat White	3·10
Latte	3·10
Cappuccino	3·10
Iced Filter	3·60
Iced Latte	3·60
Iced Espresso	2·60

An extra shot is 50p

Anita still runs Monmouth, and she's now been a part of London's coffee scene for 40 years – about eight times longer than the majority of the city's best-loved cafés. She has watched the market change, tastes adapt, and the rise of the current, all-consuming movement.

While pour-over coffee is now a fixture at many specialist coffee bars, it was a novel brewing method in the UK when Anita started making coffee this way. 'Nicholas brought us a ceramic cone, and we loved it, and had never seen it before. There was no internet, so we couldn't just look up where it came from. We knew somebody who was head of ceramics at the Royal College of Art. He copied it and made lots of little ceramic cones for us to go on top of our cups. We didn't know at that point that they were being made in Japan!' Following Anita's introduction, the pour-over filter cone has stayed trendy in the city to this day.

Anita credits the rise of the internet for the recent immense growth of, and interest in coffee, because of the increased access to information, access to quality beans and brewing equipment, and the breakdown in barriers between the coffee farmer, roaster and drinker. However, her modesty can't hide the massive impact she has had on growing the scene. Stephen Hurst, founder of the independent green bean trader Mercanta credited with pioneering speciality coffee trading, says that, 'So many coffee roasters back in the day were doing perfectly good business using mediocre beans, and the general feeling was, why on earth change that formula? So Anita Le Roy struggled to find genuine, quality driven, suppliers to fulfil her own dreams and desires for Monmouth. They were, and still are, the real deal. Their quality still counts, decades later.'

The two lines – one for hot drinks, one for takeaway beans – that spill out the door of Monmouth's Borough Market store back up this claim. For no other café would customers patiently wait in a line that loops out the door and around the corner, but for London's coffee lovers, it's worth it. Monmouth sell a monumental 1.9 tonnes of coffee over the counter from their two coffee shops every week. Their Borough counter is piled high with roasted whole bean coffee, and glistening golden coffee scoops sit atop scales, awaiting their dip into piles of single origin coffees. Beans are deposited into Monmouth's signature kraft brown paper bags, differentiated only by the brightly coloured sticker closures printed with details of the farm and the bean. Quietly, Monmouth are the leader of the speciality scene. They don't attend competitions, shows or festivals – or even advertise – but their beans speak for themselves.

'We roast about six-and-a-half tonnes a week. That's why we are so focused on the coffee, rather than going to competitions or shows!' Anita says. 'At the same time if we really want to help farmers – give them more money so they can improve the quality of their lives and their crop – then we have to sell more. We see ourselves as the last point at which a farmer can sell his or her crop. You can be theoretical or academic about it, and cup endlessly, and talk about the farmers, but unless you sell the coffee, how are you going to help them?'

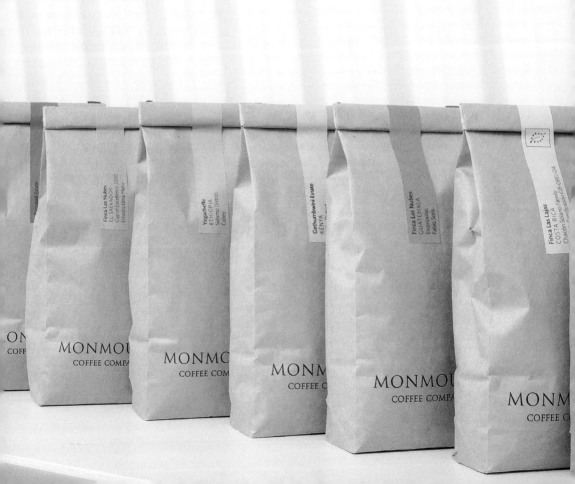

Finali Estate

Finca Las Nubes
EL SALVADOR
Cup of Excellence 2010
Ernesto Lima Mena

Yirgacheffe
ETHIOPIA
Sidamo District
Gabey

Gethumbwini Estate
KENYA

Finca Las Nubes
GUATEMALA
Esquipulas
Fabio Solis

Finca Las Lajas
COSTA RICA
Chacón Solano family GB-ORG-04
certification

MON
COFFEE

MONMOU
COFFEE COMPA

MONMO
COFFEE COM

MONMOU
COFFEE COMPA

MONM
COFFEE C

Addresses
27 Monmouth Street
London WC2H 9EU

2 Park Street
The Borough
London SE1 9AB

Website
monmouthcoffee.co.uk

Anita still runs Monmouth, and she's now been a part of London's coffee scene for 40 years – about eight times longer than the majority of the city's best-loved cafés.

Although Anita stresses that all coffee buyers, not just speciality buyers like Monmouth, have a role to play, whether they are purchasing beans for instant, pod or even coffee chains. 'I don't think a lot of people realise that every coffee farmer produces a whole range of different quality coffee – there is no such thing as a speciality farm. So every tree will produce a small amount of really great coffee, and then the rest has got to find its home somewhere. For a farm to be successful it has to find a buyer for every layer. Thank god for the large roasteries and chains. We bump into them when we are buying. They are buying good coffees. We aren't fighting each other – what they do is vitally important. The coffee industry, and the farmers we all buy coffee from, will not survive unless they are there, taking volume.'

But while the chains have been around in the UK for a while now, what Anita has been waiting for is this new movement in coffee. 'One of the things that has been really exciting about the last few years is to see this level of interest in and growth of small independent roasters. We've wanted that for years because it changes everything. It's massively powerful, because it takes good coffee – and coffee in general – to more people.'

'I love a folkloric story about the legendary queue at Monmouth Borough Market,' Stephen Hurst tells. 'The story (very likely embellished over time) goes that, one day, a patron at the back of the line, started kicking off, shouting and gesticulating: "People, what are we doing in this lengthy queue? Just to get a coffee. This is ridiculous!" He appealed for others to join him getting a coffee elsewhere. The next day the guy is back at Monmouth again, at the back of the queue. "Join me, fellow coffee people, join me," he shouts again. "Join me in this queue, in a pleasant marketplace, to await our superior cup of coffee, fresh and well roasted, carefully selected and professionally served. Let's all wait happily together here."' And people have waited patiently and happily there ever since.

SHARPS

Modern coffee bar serving speciality beans and
seven different types of milk, tucked inside
a stylish men's barber shop from New York.

'**We were one of the first "coffee and..." businesses in London, but we have a lot of coffee-only regulars – you can set your clock by them.'**

Rory MacParland, managing director, pictured

Latte in hand, the sharply dressed, Newfoundland-born manager of Sharps, Rory MacParland, stares out of the window to a quiet morning on Windmill Street, Fitzrovia. Behind him, there's a relaxed coffee shop vibe – the music gently indie, the baristas quietly chatting while brewing filter coffee, a handful of customers reading their newspapers and magazines. While this could be the scene of any number of Central London coffee shops, this one is different in that the welcoming wood-and-granite styled shop is the front for a large tiled room filled with tattooed barbers with blade razors: the core of the business, the barber shop.

'Sharps is a men's grooming company that opened in New York in 2002. We moved into this space in 2012. Because of its size, and the fact that people needed to sit and wait for their haircuts, we decided to make the front a coffee shop. It was a bit scandalous – people said the barber should be in the front window,' Rory reminisces.

Before the coffee shop opened, two baristas from TAP Coffee around the corner used to trade coffee for haircuts. 'I don't think my boys ever paid for a coffee,' Rory says. 'I thought they could use a bit of space to put together a coffee shop of their own, although they eventually moved on to do their own thing.' But the name that they made for Sharps in the coffee world stuck: it's known as one of the hit coffee shops to visit in London, even though the barber is the core of the business.

Espresso 2.0
Macchiato 2.2
Cortado 2.2
Flat White 2.4

Filter Coffee 2.

Ask the
barista!

Hot Chocolate 3.0
Iced Tea 2.4

Thé à la Menthe Pos
Spring Darjeeling
Beijing Break

Decaffeinated Coffee +20
SHARP

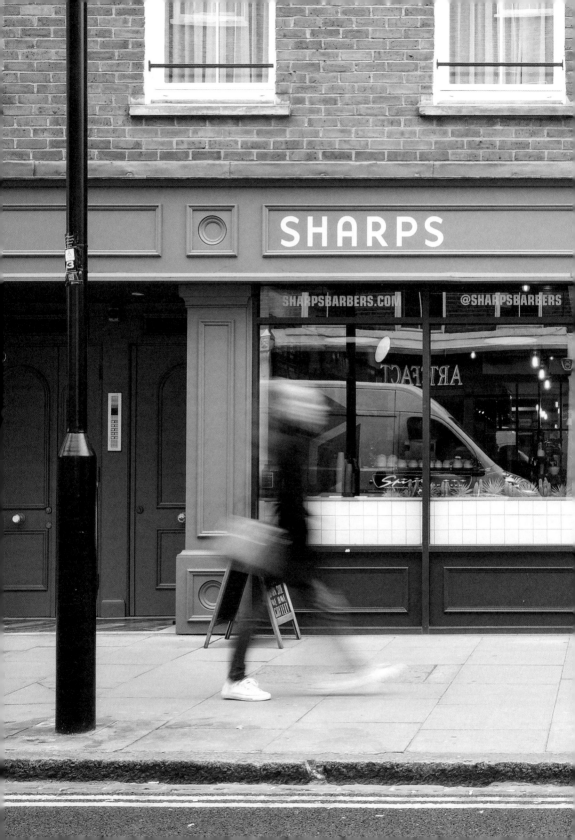

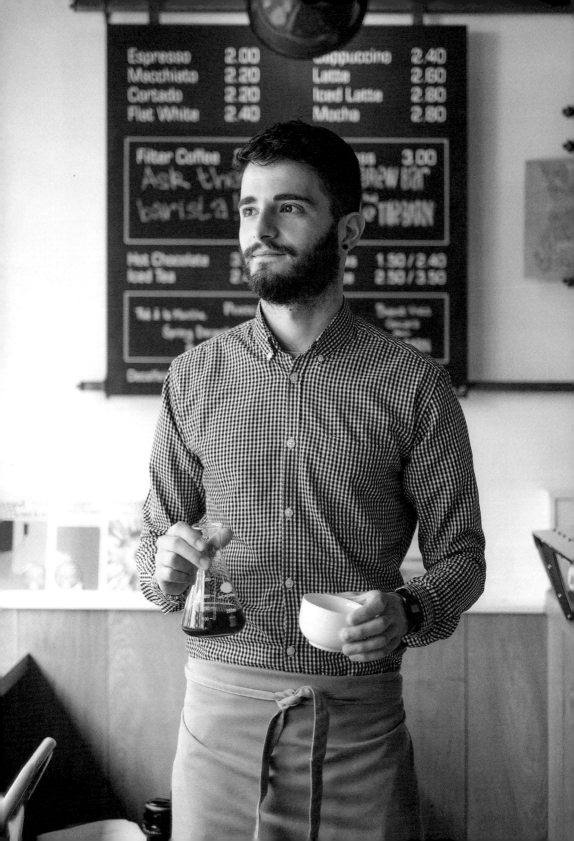

Espresso 2.00 Cappuccino 2.40
Macchiato 2.20 Latte 2.60
Cortado 2.20 Iced Latte 2.80
Flat White 2.40 Mocha 2.80

Filter Coffee 3.00
Ask the new or
barista today

Hot Chocolate 1.50/2.40
Iced Tea 2.50/3.50

Address
9 Windmill Street
London W1T 2JF

Website
sharpsbarbers.com

Follow
@sharpsbarbers

While this could be the scene of any number of Central London coffee shops, this one is different in that the welcoming wood-and-granite styled shop is the front for a large tiled room filled with tattooed barbers with blade razors: the core of the business, the barber shop.

'We were one of the first "coffee and…" businesses in London, but we have a lot of coffee-only regulars – you can set your clock by them. They come here for the baristas and for the beans,' which are some of the best in the business – they work exclusively with The Barn, the Berlin-based cult roastery revered worldwide.

'We've had a lot of great baristas through here. David Robson, who runs Soho House's coffee operation; Michael Cleland from Assembly.' Sharps certainly are passionate about making great coffee, although the benefit of the coffee business operating as a supplement to the barber is that it isn't profit driven. 'We are one of the only shops with two different types of filter on and seven different types of milk. If someone wants a goat milk latte, we have it. People come here for the coffee, but it's really about the barber shop. We wanted people to be able to have an AeroPress for free when they come to get a haircut.'

WORKSHOP COFFEE

Collection of four uniquely styled coffee shops scattered across the city and a Bethnal Green roasting hub.

'There are a lot of flash-in-the-pan fads of what to have in your range, but I'd rather have everything very good, at a non-eye watering price level.'

James Bailey, Head of Quality, pictured

Workshop Coffee opened in London in 2011, and has quickly gone from strength to strength. Now with four locations scattered across the city, they take a novel approach in the way they present their coffee and their spaces. Richard Frazier, Head of Retail, says it's purely contextual.

'When we design a new space, we try to factor in the type of area, and the people we are going to be serving. In Fitzrovia, we harked back to the Bohemian nature of coffee bars as a meeting place, somewhere to speak and share ideas, so we built a communal area, with the seating facing inwards. Marylebone is just off one of the busiest streets in the world, so we wanted to counteract that. The interiors are sharp and industrial, but there are no A-boards or obvious branding. It's quite a commercially driven area, so our space is kind of a refuge. We don't like to shout, we like to talk and wait for people to listen.'

The fact that a diverse range of customers have stopped and listened is testament to the quality of their coffee. Not using a cookie-cutter approach to design means that the company appeals broadly. 'We have an incredible range of customers,' Richard says. 'They create different environments across our spaces, giving each place its own personality. In Holborn, we are open Monday to Friday for office workers. Whereas Marylebone is full of people who want a break from shopping.'

'You can break it down, if you look at the sales of the drinks in each shop,' says James Bailey, Head of Quality. 'Marylebone for instance, easily sells the most espresso, it's a much more continental and international crowd.'

While some companies would see catering for a hugely diverse crowd as a difficulty, Richard sees it as an opportunity. 'We can trial something in a neighbourhood. Fitzrovia is the first place we had our almond milk latte. It's next to a gym with a spin studio, and lots of people were coming in and asking for alternative milks. So, we decided to make our own almond milk. We put it on the bar, it was really popular, then people started coming into our other bars and asking for it. Now we have it everywhere. We make fresh almond milk every day.'

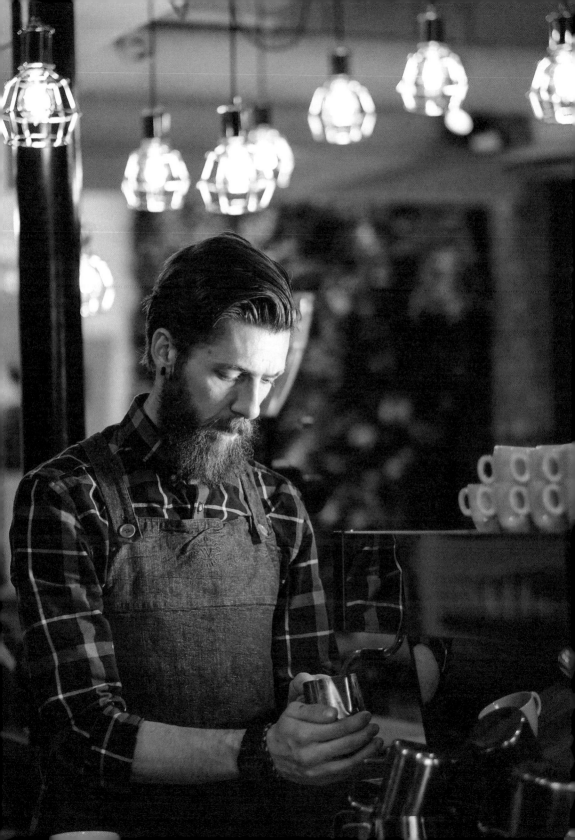

Addresses
80 Mortimer Street
London W1W 7FE

60 Holborn Viaduct
London EC1A 2FD

1 Barrett Street
London W1U 1AX

White Collar Factory
1 Old Street Yard
London EC1Y 8AF

Website
workshopcoffee.com

Follow
@workshopcoffee

'Fitzrovia is the first place we had our almond milk latte. It's next to a gym with a spin studio, and lots of people were coming in and asking for alternative milks. So, we decided to make our own almond milk.'

Richard Frazier, Head of Retail

This sort of commitment to every component is vital to creating something that people respect and trust. They taste their own coffees more frequently than is usual, and are continually looking for areas to improve. 'It sucks. We rarely enjoy our own coffee because we overanalyse it,' James says.

'The best coffee is not necessarily ever "achieved",' Richard adds, 'but it's something we always continually work towards, at every stage.' This critical analysis relies on the most fine-tuned of palates. 'James and Rich [Head of Production] do most of our buying. On their latest trip to Costa Rica, there were 200 coffees for them to try and they had to be able to say, "Coffee number two was way better than coffee number 162", which they had tasted three days later.'

'We could keep doing things the way we are and plod along and have people think of us as a 'good' roaster, but we do try and mix things up,' James explains. 'That goes for roasting, but also buying. There are a lot of flash-in-the-pan fads of what to have in your range, but I'd rather have everything very good, at a non-eye watering price level. We have a commitment to our coffee being varied, but also considered and focused.'

SQUARE MILE
COFFEE ROASTERS

Trendsetting East London coffee roasters, whose beans are served across the globe. Owned by two well-known industry leaders focusing on furthering the industry as a whole.

**'It's not just Aussies and Kiwis opening cafés here...
Be they Brazilian, South African, Korean or Japanese
– people come to London, open businesses, and bring
a little bit of something from outside of London in.'**

James Hoffmann, co-founder, pictured previously

At the heart of any great business – be it in technology, food or Frisbee – are the people that saw potential in a spark of an idea and took a chance. Looked up to by the ones that follow, they often lead and shape their industries into the future. Respected, passionate, dedicated and knowledgeable, James Hoffmann and Anette Moldvaer of Square Mile Coffee are a perfect example of what modern London coffee is all about.

James and Anette's skills combined to cover everything needed to run a successful coffee business. Square Mile was set up in 2008 after James became World Barista Champion, and Anette World Cupping Champion. While they had originally set out to open up a roastery café, the pair found they had chosen a difficult year in which to start a business. So instead they opened a coffee roasters, with the intention of supplying quality-focused cafés around London.

Creating a supply business for a fledgling industry came with its own set of challenges – rather than winning customers, the duo discovered they'd need to help create them. To develop their own business they'd need to nurture the scene. To this day, many people speak fondly of the guidance and help James,

Anette and Square Mile gave to an industry getting on to its feet.

'One of the things we set out to do was to make London famous for good coffee,' Anette says. 'I don't think that ten years ago London would have come to mind as a city for good coffee. But we are up there now.'

Anette heads up sourcing, buying and roasting at Square Mile and, with her roasting team of three, produces a casual three tonnes of fresh coffee per week. She has also brought a little of her native Norwegian coffee culture to the London scene. 'I'm from a very filter coffee-oriented country. At Square Mile we've gone from roasting 12 per cent of our coffee for filter to close to 25 per cent now – it's great.'

James thinks that the success of London's coffee scene can be attributed to the diversity of the city, which keeps the coffee scene fresh. 'It's not just Aussies and Kiwis opening cafés here, contrary to popular opinion. Be they Brazilian, South African, Korean or Japanese – people come to London, open businesses, and bring a little bit of something from outside of London in. That's always been London's strength, and that's what makes it the most fun, the most exciting. There's possibility here that is unusual compared to other cities.'

SQUARE MILE
COFFEE ROASTERS

SEASONAL ESPRESSO

RED BRICK

CARAMEL/RASPBERRY/CHOCOLATE

40% Derrubada, Brazil / 40% Serrania,
Colombia / 20% Mulish, Ethiopia

ROASTED: 02/03/17 #1 2Kg NET

Creating a supply business for a fledgling industry came with its own set of challenges – rather than winning customers, the duo discovered they'd need to help create them. To this day, many people speak fondly of the guidance and help James, Anette and Square Mile gave to an industry getting on to its feet.

During their time roasting coffee in a converted industrial warehouse in East London, they've seen huge changes happen across the industry, and not just in the types of brewing methods people are interested in. Primarily, they've seen an increase in accessibility. 'There are more cafés making good coffee, there are more roasters roasting good coffee, there are more importers bringing in good coffee – it's just easier to get to,' Anette says.

While the industry has gone through an immense recent boom, and some are worried that London is reaching saturation point, James thinks that there's still a lot of untapped potential. 'Customers might not yet have been enticed in because we made the qualifications for entry a little bit high, in that you must understand everything, and you must care. That's where craft beer did a slightly better job than craft coffee – you didn't have to care to drink interesting craft beer.'

Anette agrees: 'It really shouldn't be intimidating to walk into a place that will serve you a great cup of coffee for the same price as a mediocre cup of coffee two doors down.'

'Then there's the other side in that it takes as long to uncap a bottle of craft beer as it does to uncap a bottle of a non-craft beer, but to make a good coffee generally takes independent businesses a lot longer than it takes the chains,' James says. 'That's why your average chain does 550 tickets a day and your average independent does 350. Some people value convenience and speed. There's nothing that stops these customers buying speciality instead, other than we aren't doing a good enough job meeting their needs. Which is good, because it means there's an actual problem and as an industry we can fix it.'

James and Anette's thoughts on the coffee scene are easy to come by, and their ideas have already had a substantial impact on the industry – arguably, worldwide. James' blog, Jimseven, and book, *The World Atlas of Coffee*, sit alongside Anette's *Coffee Obsession*; all of which are widely read and respected well beyond the bounds of this city. While they've influenced many aspects of the industry already, next on the agenda is sustainability.

Website
shop.squaremilecoffee.com

Follow
@squaremilecoffee

'Coffee can often be extremely abstract. It's about shrinking that world, and then trying to leverage that world to do something useful.'

James Hoffmann, co-founder, pictured previously

'You look at all the waste you push onto your customers and you feel bad about it. We are very wasteful as an industry still,' James says. 'You don't get many chances for messaging and we will always lead with the quality of what we do. So we don't really get to talk about our efforts in sustainability, but for one, we are trying to get rid of cardboard. We are going to ship in reusable boxes that our customers ship back. We also take any roasters' foil bags back; there's no point that going to landfill when we can get it recycled.'

Other efforts to utilise waste have seen Square Mile pioneer innovative uses for coffee 'waste products', such as cascara, the fruit found around the coffee bean. Usually thrown away, Square Mile were the first to bring cascara into the UK. 'Cascara is still seen as a waste product,' James laments. 'It's kind of odd that coffee farmers are fruit farmers that never really get to sell their fruit – and it can be delicious and interesting. We always want to do interesting things, if only to get other people thinking about it. It's kind of the point – not to own the thing, but to push an idea forwards.'

Square Mile's 2016 London Coffee Festival stall also aimed to challenge and inspire the industry to think about coffee in a different way, by designing a tasting menu of foods made with these coffee by-products. 'We made a Red Brick [their house espresso] rye bread topped with a chaff butter. We made cascara chocolate. And cascara soda. And cascara gummies!' James says.

It could be argued that the London coffee scene is so open, welcoming and successful because of the attitudes of people like James and Anette. It is not often you'll find a for-profit company with such a focus on furthering their industry. 'Coffee can often be extremely abstract,' James says. 'It's about shrinking that world, and then trying to leverage that world to do something useful. There's a tonne of opportunity.'

LOOK MUM NO HANDS!

Community-focused cycle café serving up craft beer, speciality coffee and cycle repairs in an open-plan Old Street location.

'We just really wanted to combine the things that we liked – and that was good coffee, good beer and fixing bikes.'

Lewin Chalkley, pictured (right) with Matt Harper and Sam Humpheson, co-founders

One modern trend in space design, prominent in London, is to connect the element of craft with the consumer directly. In coffee, roasters are opening up their workshops and roasting spaces as cafés, and roasting and packing alongside their coffee-drinking customers. This 'open studio' style design often has the benefit of developing a community and enhancing interest in and knowledge about the genesis of our daily drink. Look Mum No Hands! takes this open workshop philosophy, but does it a little differently. Welcome to one of London's well-loved 'cycle cafés'.

Co-founder Lewin Chalkley wanted to ensure that both sides of the bike workshop-slash-speciality-coffee-bar business could stand on their own two feet. 'There were a few bike cafés when we started but they were either a bike shop first and they just stuck a coffee machine in the corner, or they had a café and they stuck a bike on the wall. It works for us here because there's an intangible cross pollination that goes on – people come in with a flat tyre and they can buy a good coffee while they wait. Then we have all these customers who come and meet, work – they come for the coffee. I can't quantify how it works, but it does.'

'My background was in food and drink.

I got a job in Pret a Manger to clear an overdraft. I never cleared the overdraft, but found myself in coffee and catering,' Lewin laughs. He and business partners Sam and Matt bonded over a love of cycling, although they all brought their own skills and expertise to the business. Lewin was into coffee, while Sam had been working in bike shops, and Matt had just left his job as a banker. Together they had all the elements needed, so the three sought out their space on Old Street and have never looked back.

'Three blokes, into bikes,' Lewin says. 'We just really wanted to combine the things that we liked – and that was good coffee, good beer and fixing bikes. It's all very organic; we didn't, and still don't, have a master plan.'

The origins of the name resonate with anyone who owned a bike as a child – or who owns a child – and Lewin thinks that they owe the name a lot of their success. 'Finding a name for a café is a little like trying to find a name for a band. We were brainstorming, and Look Mum No Hands! came up at about 2:30am among about 200 different names. I was so fed up I would have picked anything, but I'm really glad we picked it now. I think the name is responsible for us growing into a brand, as it makes sense to everybody all around the world.'

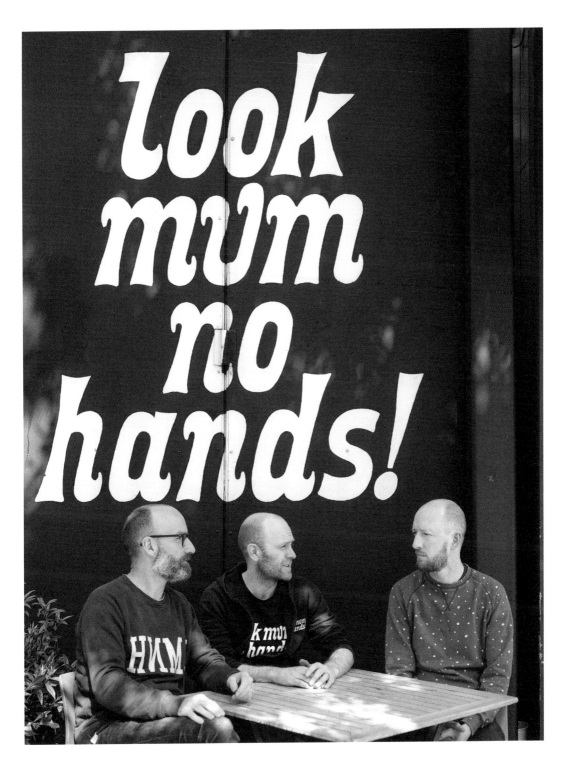

Addresses

Café/bar/workshop
49 Old Street
London EC1V 9HX

LMNH Kitchen
101 Back Church Lane
London E1 1LU

Website
lookmumnohands.com

Follow
@1ookmumnohands

The origins of the name resonate with anyone who owned a bike as a child – or who owns a child – and Lewin thinks that they owe the name a lot of their success.

The space has a wonderful community feel too. There is an air of welcome: whether you are a Lycra-clad cyclist, a mother with a pram or a laptop-toting creative, there's a seat for you. 'There's seven years of dirty fingermarks and "Dave was 'ere" scratched into the tables now. It has a nice patina,' Lewin smiles. There are bikes all over the walls, along with helmets, coffee cups, brightly coloured cushions and disco balls – you name it. 'I put these prints up this morning. I hung them from the ceiling with brake cables – it works!'

'As a small business, you need to cast your net nice and wide but make sure the offering is quality,' Lewin advises. 'Businesses have to adapt to survive. The big chains have economies of scale whereas we have to be more innovative. But I think it's more interesting this way, isn't it?'

Multi-roaster café and training school
Clerkenwell

PRUFROCK COFFEE

Unofficial coffee 'embassy' and café on Leather Lane
frequented by the coffee cognoscenti with a friendly,
relaxed training school.

'We try and stay ahead of the curve; we don't want to end up some sort of banjo band revivalist movement.'

Jem Challender, co-founder, pictured

What is in a name? Quite a lot, when it comes to one of the undisputed top coffee shops in London. 'It's a bit of a dig at my business partner, Gwilym Davies,' laughs co-founder and Director of Training, Jem Challender, 'because "The Love Song of J. Alfred Prufrock" by T. S. Eliot contains the line, "I have measured out my life with coffee spoons", and this is definitely not a good thing to have done. Leading a life of obligation, and maybe lacking ambition and freeloading, Prufrock is, well, a little like Gwilym. This was before he was the World Barista Champion, of course!'

It's hard to see either of the founders lacking in ambition, having built one of the most respected coffee shops and training schools in the industry in a matter of years. But the literary name also seems to allude to the timelessness of the café. With a modern yet trend-free design and a friendly, communal feel, you could almost see T. S. Eliot himself writing in a corner, perhaps next to a 1980s down-and-out punk band coming straight from a long night in Camden.

London's coffee cognoscenti order filter coffees and chat with their peers here. Prufrock is the modern embodiment of the historic London coffeehouse: that meeting place teeming with life, business and art that was the caffeinated bloodline of London during the seventeenth and eighteenth centuries. 'Our reputation is as more of an embassy,' Jem says. 'That's how we'd like it to be – not specifically promoting an agenda, but being impartial.'

'We started out running market carts. That is where Gwilym was when he won the barista championships. The coffee world saw it as a rags-to-riches story – he was living on a canal boat, and I was playing rock and roll music. We didn't really describe ourselves as baristas at the time. We viewed that as a Starbucks term.'

These days, though, 'barista' is a more common career choice, and the Prufrock café is filled with talented young people from all over the world who've come to London with a passion for coffee. Opened in 2009 on Leather Lane, their kitchen staff cook up homemade food to match their high-end coffee. From chocolate and cardamom cookies, cinnamon buns and brioche, to tarts, sausage rolls and stews, everything is made in-house from ingredients sourced from notable UK organic and ethical farms.

Address
23-25 Leather Lane
London EC1N 7TE

Website
prufrockcoffee.com

Follow
@prufrockcoffee

The literary name alludes to the timelessness of the café. With a modern yet trend-free design and a friendly, communal feel, you could almost see T. S. Eliot himself writing in a corner.

Prufrock is also one of the only places in London to offer professional-level coffee courses, running classes almost every day of the week. They offer accredited courses in roasting, barista skills and sensory elements, down to introductory classes for passionate beginners. Jem explains, 'At a time when we might have done another café site, we started training instead. We drifted more into being a multi-roaster café, a knowledge centre for trends in coffee, roasting skills and selecting beans.'

The educational component is key to keeping the café and business relevant, especially as the industry adapts to more automated procedures and methods. 'A lot of the smartest people I know are focused on the fact that there has to be a better way of extracting coffee than the espresso machine. I quite enjoy watching all the startup innovation – I think there's going to be loads more of that.'

The embassy-like nature of Prufrock means they are on top of new innovation before anyone else. 'We get to beta test lots of cool stuff as the industry advances. We try and stay ahead of the curve; we don't want to end up some sort of banjo band revivalist movement.'

For all their knowledge and success, their modesty is legitimate. It's this that pushes them further and will keep them at the top of their game. 'We didn't know much when we started,' says Jem. 'And we don't know a lot more now – we are always hyperaware of how much more there is to learn.'

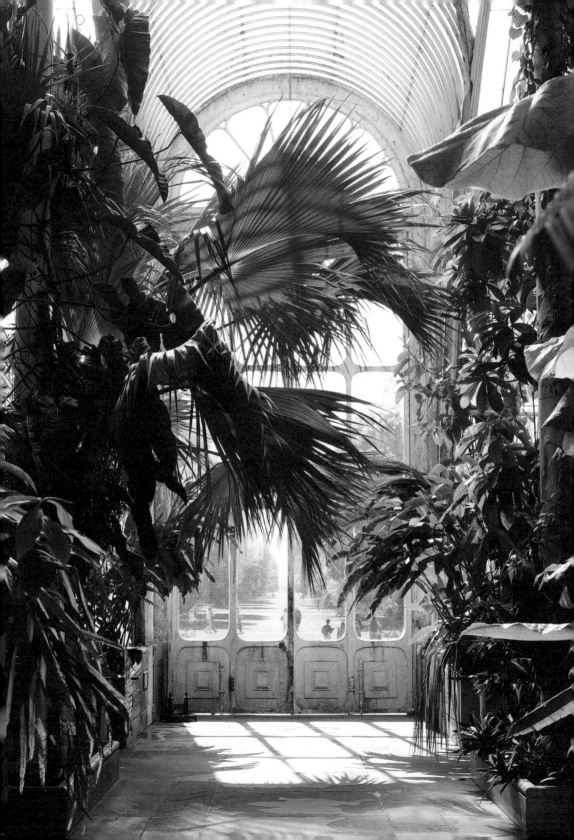

KEW GARDENS
COFFEE RESEARCH

Pioneering scientists from Kew Gardens working
on groundbreaking research into the coffee plant,
sustainability, growing regions and more.
Securing a future for our daily drink.

'We have about seven million specimens – it's the largest collection in the world.'

Dr Aaron Davis, Head of Coffee Research, pictured (middle)
alongside Tim Wilkinson, Jenny Williams, Susana Baena,
Justin Moat, Coffee Research team

Behind the scenes at the Royal Botanic Gardens in Kew, 500 scientists work to preserve the biodiversity of our planet. A handful of these make up the coffee team, who are striving to protect, preserve and develop the much-loved plant to ensure our continued daily enjoyment for centuries to come. Their job is to discover new species, work with farmers to increase the sustainability of their crops, test climate-resilient varieties, map entire countries to determine the best areas to plant, and work with food scientists to determine the chemical compounds that contribute to flavour. They also work closely with the coffee industry, as their work has huge application for farmers, roasters, coffee businesses and consumers alike.

Dr Aaron Davis is the Head of Coffee Research at Kew. On any given day, he can be found poring over specimens in a wing of Kew's Herbarium, built in 1877. 'We haven't counted everything, but we have about seven million specimens – it's the largest collection in the world. I think I have been through about 90 per cent,' Aaron laughs. 'We never throw anything away! We have a coffee pot from Oman, we have coffee leaf tea made in the early 1900s. Sprudge [an international coffee news outlet] came in after the London Coffee Festival. They picked up a coffee mill made from tropical hardwood and said, "Is anything new?" It was probably made around 1860–70, but it looks just like a modern Hario burr grinder.'

During colonial times, the British believed there was great economic potential for coffee. Research and development accelerated at a breakneck pace, and Kew was at the heart. Scientists and explorers were sent around the world and everything they found was shipped back to Kew to study. These historic items and specimens are stored in the Herbarium and help Aaron in tracing coffee's movement around the globe, as well as answering some pressing modern questions.

'In Uganda they've recently had some weird DNA results. I looked back in the collections of photographs and specimens and pieced together that, way back, the Dutch sent us some Robusta beans from West Africa, we grew them, and then we sent some plants to Uganda. None of this is in books or records; it's just buried in the data sources here in the archives.'

Dr Davis came to Kew in 1987 as a tropical botanist, and has been working specifically with coffee since 1996. 'I came here on a post-doctoral contract to study coffees of Madagascar. My boss said, "you probably won't find very much", but I found 20 new species. And the species were amazing; they weren't just a bit different. We found the world's largest coffee bean, the world's smallest coffee flowers, the world's smallest coffee bean.'

Roughly 125 species of coffee have been discovered to date, and Aaron and his colleagues have discovered about 25 of them. 'I've got another 15 still in my to-do tray,' Aaron laughs.

Surrounded by so much scientific study and new discovery, it's easy to forget that only roughly 125 species of coffee have been discovered to date – and the fact that Aaron and his colleagues have discovered about 25 of them is an easy way to prove their immense contribution to coffee worldwide. 'I've got another 15 still in my to-do tray,' Aaron laughs – which will mean that once logged, they have discovered almost one third of the world's known coffee varieties.

Some of the most important work that the Kew coffee team does to improve, preserve and protect our coffee from the impacts of the future is through their sustainability projects. Justin Moat is the man behind the hard data that will help Ethiopian growers confront the difficulties ahead. 'Aaron started bringing stuff back from Ethiopia and said we have an issue with climate change here – crops are dying out, farmers are reporting problems. I thought, I've got the information, I can do something about that.'

'Justin runs the modelling team. He tells me he's the brains and I'm the poet,' laughs Aaron. 'We have been working out what is going to happen with climate change. We schlepped our way around 35,000 kilometres-plus collecting the data, and then Justin analyses it. We are building a coffee atlas of Ethiopia. It essentially tells you where coffee is growing, it tells you if it's a great place or a terrible place. It gives you the origins and the terroirs, and then this gives a platform for planning the future for coffee in Ethiopia. If we don't do anything we are in trouble. But if we can make science-based decisions...'

Justin is able to simulate the effects of drought, temperature change and an array of other factors that could potentially reduce or increase coffee production. This research is invaluable in creating a climate change plan before it's too late.

'When we first went public with our results, everyone started tweeting us,' Justin says. 'We had lots of climate deniers, but my favourite tweet was, "Fuck climate change. This is my coffee you are talking about!" We did a big project and it came out that one in five plants are threatened with extinction. One of the questions was "why should I care?". It's difficult unless you can connect with what people eat or drink.' Aaron agrees that coffee is a good flagship species for biodiversity conservation. 'If we tell them Arabica is in danger, people say, "What? I drink that every day!"'

While mapping the land and the growing potential is exceptionally important, the coffee team's work doesn't end there. 'Where we would like to go next is look at developing new coffees. In a resilience strategy, if you have to move coffee growing as the climate changes, that's not ideal. What you want is for people to stay on their land,' Aaron says. 'We are trying to use wild diversity and breeding programmes to produce climate-resilient coffee.'

Address
Royal Botanic Gardens
Kew, Richmond
Surrey TW9 3AE

Website
kew.org

Follow
@kewgardens

'We had lots of climate deniers, but my favourite tweet was "Fuck Climate Change. This is my coffee you are talking about!"'

Justin Moat, Research Leader: Spatial Analysis

Coffee companies from Union to Starbucks are also keen to work with and learn from these coffee experts. Aaron and his team have assisted growers, farmers, governments and coffee companies – but some of their more recent work may further help roasters and baristas too. 'This year we started working with food scientists for the first time,' Aaron says, 'looking at coffee chemistry, specific chemicals that influence cup profile.'

Although there isn't yet a portal for general public access to all of their scientific findings, they will share with anyone who asks. 'We want to make a discovery, write a paper and make it public domain. We are duty bound to share knowledge,' Aaron says. 'It's also about making people aware there is a huge amount of coffee science already available. People come up with an idea for a study and it's often already been done in the 1980s, or even the 1940s.'

The entire coffee world benefits daily from the work of these scientists and their forebears. So much of what we know about coffee can be traced back to research done at Kew: there is no better proof that London is one of the most important places for coffee in the world.

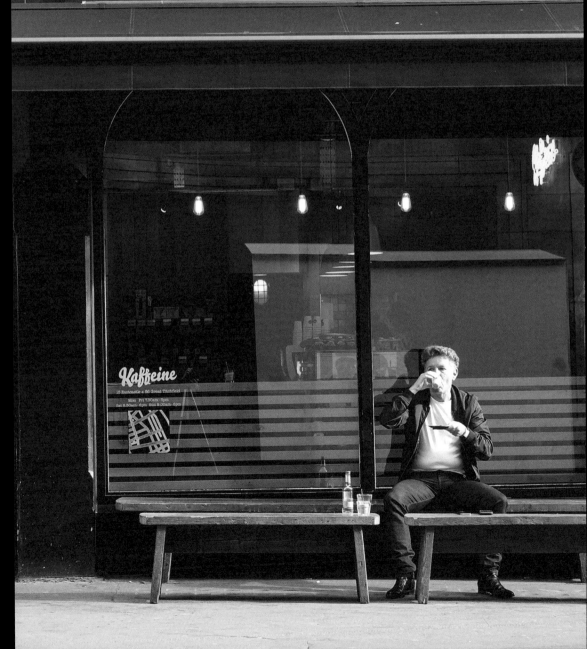

KAFFEINE

Central London cafés pairing great espresso coffee
with homemade food, and a sprinkle of laidback
Australian hospitality.

'I'm not here to expand exponentially... I just want to be one of the best.'

Peter Dore-Smith, founder and director, pictured

Between roughly 2005 and 2010, various expatriates of Australian and New Zealand made their way to London and led the charge setting up the high quality, inclusive, speciality cafés so common in their homelands. While London indeed already had a long history with coffee, the Australian coffee culture brought a unique perspective to an age-old tradition. In Australia, food and coffee are inextricably linked – and quality of the bean was paramount. Good, friendly and efficient service is also the key, says Peter Dore-Smith, the founder and director of Kaffeine, and he should probably be trusted – he's a Melbournian with 30 years' hospitality experience.

While the Antipodeans certainly saw a gap in the market for the style of laidback café they had grown used to back at home, many just wanted their morning coffee. Catherine Seay, Melbourne-born owner of Curators Coffee and an ex-Kaffeine barista, says, 'We needed our coffee – so we couldn't leave the coffee industry, because who would make our coffee then!'

'I came to London in 1995 and stayed here for three years,' Peter says. 'When I went back to Melbourne, I noticed a change in the café culture. There were cafés that were architecturally designed, food orientated, where the coffee was better, where people wanted to go and hang out. I came back to London in 2005 with my wife, and we tried to go out for our Australian-style coffee. One day I was walking down Berwick Street and we found Flat White. I went in there and had a coffee, and then rang my wife – we'd finally found an Australian coffee place.'

Flat White was one of the original 'Aussie-style' cafés in London, and entered the scene just at the right time. While London's coffee culture was slowly evolving from the 1950s espresso boom, brought primarily into Soho by Italians after the war, the integration of the Antipodean coffee business owner certainly accelerated the growth and expansion of the artisan coffee shop common today.

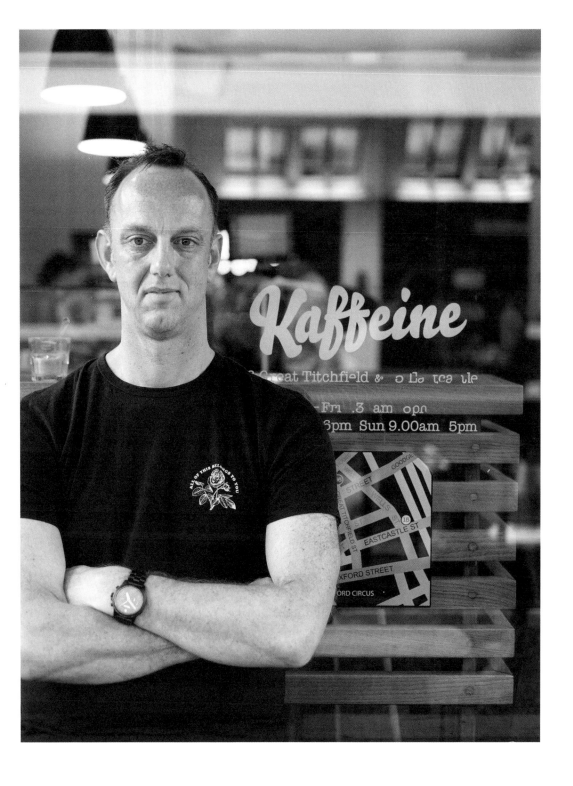

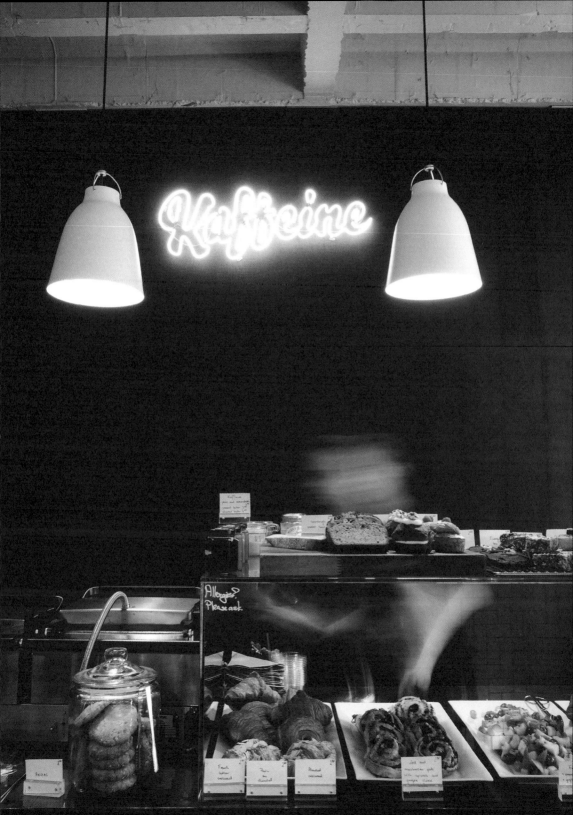

Addresses
66 Great Titchfield Street
London W1W 7QJ

15 Eastcastle
London W1T 3AY

Website
kaffeine.co.uk

Follow
@kaffeinelondon

Peter wanted to bring the entire experience of a Melbourne café, offering an all-inclusive service – not just good coffee. It was only just over a year into business, and Kaffeine was voted best independent coffee shop in Europe.

However, Peter wanted to bring the entire experience of a Melbourne café, offering an all-inclusive service – not just good coffee. 'I always knew I wanted my own place. The food culture was really picking up since I had last been in London, but while there may have been a place that did great coffee, and another place that did great food – I wanted to do both.'

So in August 2009, Peter flung open the doors to Kaffeine on Great Titchfield Street, welcoming in customers for quality food made on site and excellent coffee. Following in the Melbourne coffee tradition of espresso – also brought to that city by Italian immigrants in the 1940s and '50s – there's not a filter in sight. While other cafés have since sold up or expanded, you can still find Peter at Great Titchfield Street, behind the coffee machine or till, bringing home his passion for good hospitality. 'I'm not here to expand exponentially and have the most coffee shops in the UK – I just want to be one of the best,' he says.

And it didn't take long for the industry to see him as such – it was only just over a year into business and Kaffeine was voted best independent coffee shop in Europe by industry professionals at the Allegra Coffee Symposium. 'From then on, we thought, well if that's how we are viewed – and it was a huge compliment – then that's what we always want to be. We want to always be regarded as one of the best coffee shops in the UK.' And almost a decade later, they still are.

CARAVAN

All-day dining restaurants in three locations,
serving a 'world menu' and roasting their own
speciality coffee on site.

'When we moved here in 2001, we realised that there were only the chains. We had come from New Zealand where we have a rich heritage in speciality coffee going back 30 years.'

Laura Harper-Hinton, pictured (middle), with Chris Ammermann and Miles Kirby, co-founders

The influence of Antipodean expats is strong in London's coffee and food scene. Three friends – Laura Harper-Hinton, Miles Kirby and Chris Ammermann – had worked in restaurants and coffee back in New Zealand, and had always planned on opening a place of their own. After moving to London in 2001, they continued working in restaurants for almost a decade to amass the capital, and finally in 2010, Caravan Coffee in Exmouth Market was born. At the time, it was a novel concept – all-day dining with in-house coffee roasting. Laura says, 'When we moved here, we realised that there were only the chains. We had come from New Zealand where we have a rich heritage in speciality coffee going back 30 years.'

'I think having an open customer-facing roastery was a big part of it – we were one of the first in London to have that,' says Mike Logue, Head of Operations. This exciting concept, originally housed in the small, neighbourhood café, was amplified when the team took on their next space in King's Cross – an immense, converted Victorian Grade II-listed grain store. Their coffee roasting moved to this site, and their dining concept expanded to a full-blown restaurant.

On moving to King's Cross, Caravan began to have an even larger focus on the food, staying open all day from breakfast through to dinner and drinks. Staff weave throughout the massive, open-plan dining hall, carrying espresso, filter coffee, cocktails, house-made sodas, tonics, kombuchas and drinking vinegars (some uniquely made with coffee). The food and aroma speaks of a global menu starring dishes such as Burmese chicken salad, date and onion pastillas, chaat masala oxtail, red curry seabass and coconut bread – alongside traditional pizzas and that much-loved brunch dish of avocados and chilli on sourdough toast. On a breakfast visit, make sure not to miss their house-made peanut and miso butter on toast, or their grain pancakes with soft poached nectarines and almond liqueur mascarpone.

Mike Logue explains that the business's name hints at their approach to the menu. 'Our concept is "well-travelled". The founders, from their years of travelling around, have picked up a lot of stuff along the way. It refers to an old school traveller's caravan.' Laura adds: 'We call our food well-travelled, in the sense that it's not tied to any particular geographical region. It gives us loads of awesome flexibility in what we put on our menu, and likewise with coffee, it comes from all over the world.'

The coffee roastery is now a separate part of the business, roasting for cafés across the country – but their own restaurants are still their largest customer. This is key as it allows them a lot of creative freedom. 'One thing that we definitely love doing is special projects,' Laura says. 'Everyone wants to be challenging themselves and doing something different every day. The restaurant allows us to do that.' The Caravan team run a variety of exclusive projects throughout the year, and keep their food menu fresh and changing – so are worth more than one visit.

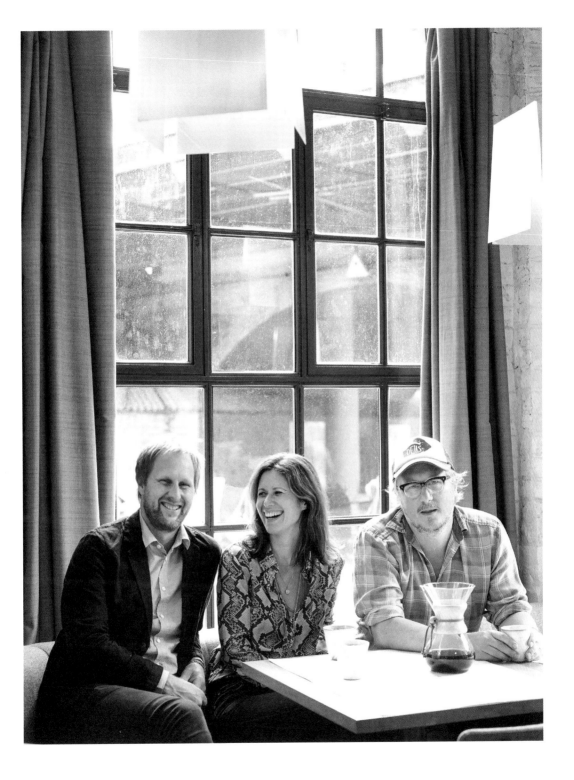

Sam Langdon, Head of Coffee

Addresses
1 Granary Square
London N1C 4AA

11-13 Exmouth Market
London EC1R 4QD

30 Great Guildford Street
London SE1 0HS

Website
caravanrestaurants.co.uk

Follow
@caravanroastery

'Our concept is "well-travelled". The founders, from their years of travelling around, have picked up a lot of stuff along the way. Our name refers to an old school traveller's caravan.'

Mike Logue, Head of Operations.

'We've just completed our second year of sponsoring the Coffee Masters competition,' Mike says. 'It's been an exciting opportunity and challenge. Our green buyers have loved it because they get to go out and find the best coffee, with money no object – it's a dream job. It's literally to go and find nine of the best coffees you can, from anywhere in the world, and bring them back, roast them and they are then used for the competition. After the first year, we thought, we don't just want to give this to competitors, we want to get this out to the public. So we thought up The Niners.'

The Niners runs throughout London Coffee Week and London Coffee Festival – the internationally renowned annual celebration of new, innovative and inspiring things the coffee scene has to offer. Caravan's creative spirit brings the excitement of the professional coffee competitions to the general public. 'The nine coffees from the competition go on sale at the beginning of the coffee festival as a set, but their identities are kept a secret until the end of the competition. We challenge people to be coffee masters too,' Mike says.

'This year we added The Niners tour – we chose nine cafés in London and each showcased one of the coffees. You'd have a loyalty card and get a stamp for each one you tried, and then you could redeem it for things on our website. It's a huge amount of work, and the truth is it costs us a lot, but it's great fun and it's good to do things a little bit differently. This is the only way you are going to be able to push speciality coffee out to a larger audience. When it's just a bag of beans, there's little interest in it for a lot of people, because they think they can just buy that on the shelf in the supermarket.'

Laura thinks that the nature of the city itself is the perfect foundation for the diverse and intriguing coffee scene we are enjoying today, and that while New Zealanders and Australians may have had a driving influence, the London scene has evolved, expanded and truly become unique. 'Londoners are so open-minded, multicultural and embracing of new concepts. Because we have a fantastic volume of people here, who all want to try out new stuff, it's a breeding ground for new ideas, technology, development. London is an absolute hotspot.'